THE
NEW IMAGE
PAINTING IN THE 1980s

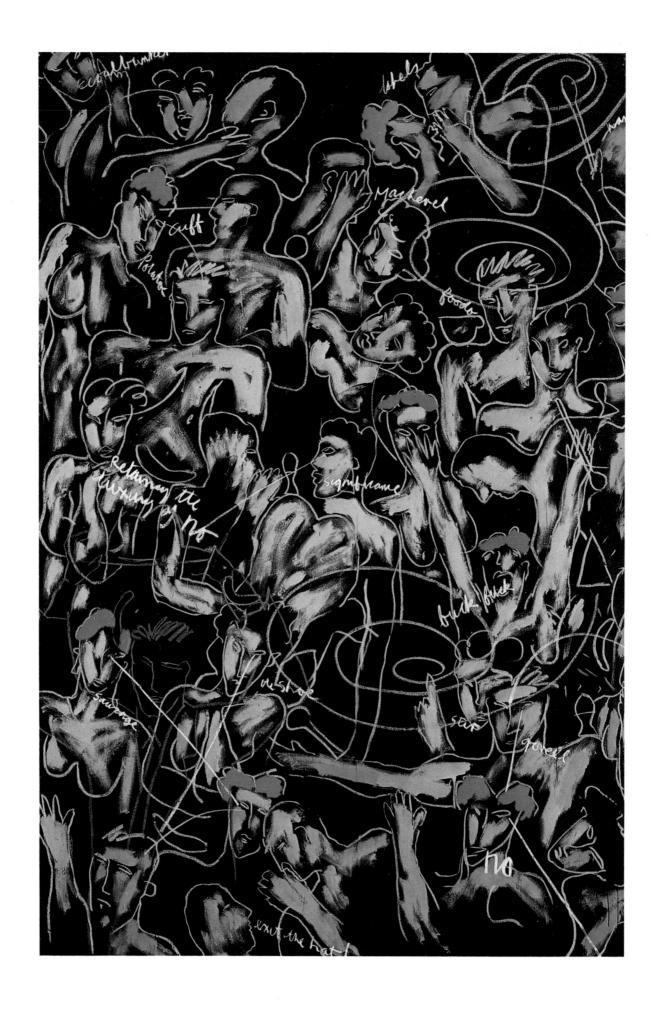

THE
NEW IMAGE
PAINTING IN THE 1980s

TONY GODFREY

PHAIDON · OXFORD

For Peggy

Phaidon Press Limited, Littlegate House, St. Ebbe's Street, Oxford OX1 1SQ
First published 1986
© Phaidon Press Limited, 1986

British Library Cataloguing in Publication Data

Godfrey, Tony
　The new image in painting.
　1. Painting, Modern—20th century
　I. Title
　759.06　ND195

　ISBN 0–7148–2403–8

Printed in Portugal by Printer Portugesa, Lisbon

Acknowledgements

I would like to thank all those who helped produce this book. Informing all I have written are the many discussions and arguments I have had with artists in this book, in particular Jorg Immendorff, Per Kirkeby, Robert Kushner, Christopher Le Brun, Ian McKeever and Brice Marden. Among others whose help and comments have been invaluable are Lynne Cooke, Gerlinde Gabriel, Carrie Tuke and Peter White, Matt Collinge of *Artscribe International* and Richard Shone of the *Burlington Magazine*. Of the many people in commercial galleries who have helped find photographs and information an especial debt is owed to Judy Adam and Maggie Bolt, likewise to my editor at Phaidon, Penelope Marcus, for her advice and encouragement.

Frontispiece. Bruce McLean. *Exit the Hat*. 1982. Acrylic on canvas, 400 × 300 cm. (157 × 118 in.) Private collection

CONTENTS

Introduction 7
1 The Visigoths enter Rome 9
2 Speaking in German again 21
3 Italian Colour, Poetry and Skulls 65
4 British Painting at the Crossroads 89
5 The Death of the School of Paris 105
6 New York – when the Worlds collide 119
7 An Icon of the Twenty-first Century 153
Select Bibliography 157
Index 158

1. Steven Campbell. *Fern's Revenge – Pool*. 1984. Indian ink on paper, 272 × 246 cm. (107 × 97 in.) Private collection

─────── INTRODUCTION

A few years ago, I was in conversation with an Italian art critic when out of the blue, and quite categorically, he asserted that painting had been reinvented in 1977 by the young Italian painter Sandro Chia. It was the sort of mendacious claim that Italian art critics all too often make, and at the time I thought little of the remark, simply putting it down as a ludicrous over-statement. After all, painters had been painting non-stop for centuries: none of them had *forgotten* how to paint. How then could it be reinvented?

It was only on reflection that I realized that there was a certain perverse truth to the assertion. At the end of the seventies and beginning of the eighties a phenomenon known as the New Painting had emerged, firstly in Germany and Italy, then subsequently in the United States, Great Britain and France (the five countries on which this book concentrates). By 1985, when related tendencies were emerging in places as far apart as Japan, Spain and Australia, it was apparent that the state of painting had been totally changed.

In what way, and to what extent painting has actually been *reinvented*, is the question that this book sets out to answer.

2. Julian Schnabel. *Drawing in the Rain (in Barbados) – Head*. 1981. Ink on paper, 101 × 76 cm. (40 × 30 in.)
Private collection

THE VISIGOTHS ENTER ROME

There always remains the problem of art, of painting; its mystery and all the myths which have been created and which can be created around painting.

Mimmo Paladino

In 1965, the important American Minimalist sculptor and writer Donald Judd proclaimed painting was dead. It, and all its traditions, seemed played out. The avant-garde was dominated by work that, like his, had rejected the ethos of *belle peinture*. Advanced art, or art that wanted to reflect its society must, it seemed, engage with the new media of video, film, performance, or else be made with Minimalist or Conceptual preconceptions. To many intelligent people in the art world, it appeared obvious that painting had run its course and could be left to the Sunday painters and pavement artists. The Conceptual artist Victor Burgin spoke for many when he subsequently said: 'I'd given up painting in '65 for the rather crude reason that it was an outmoded technology. There were enough paintings and sculptures silting up basements of museums all over the world – why produce more? It was ecologically unsound: a form of pollution.'

Although many artists continued to paint, it no longer was the central activity of visual art as it had been for several centuries. To the unsympathetic, the painting that was still produced seemed formally and spiritually bankrupt. In their view, most figurative painters had their heads firmly in the sand, making pictures in the old, traditional ways as though nothing had changed during this century. Pop painting, with its smart reprocessing of mass-media imagery, seemed chic rather than challenging. But their greatest antagonism was to the abstract painters, who continued producing under the aegis of the formalist critic Clement Greenberg. He asserted that in order to achieve quality and purity, painting must eschew any concerns other than those of flatness, shape of support and the properties of pigment. The results, though sometimes beautiful, were all too often vacuous and the insult, 'the aesthetics of boredom', described their ethos with depressing accuracy. All in all, it seemed to have as little to do with life in the street outside as the work of any other academic art.

Painting was to return to centre stage, but in a different guise to any of these three styles. It was about a totally different kind of painting that Christos

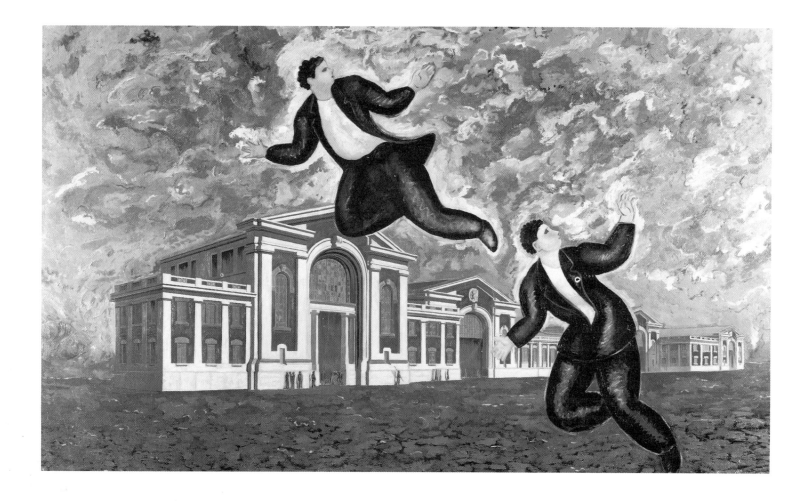

Joachimides wrote, in 1981, in the catalogue to the exhibition *The New Spirit in Painting*: 'The artists' studios are full of paint again and an abandoned easel in an art school has become a rare sight. Wherever you look in Europe or America you find artists who have rediscovered the sheer joy of painting.'

This New Painting, as it became known, took up the old (but lately often discarded) ambition of painters to express their feelings and to show the wishes, dreams and conflicts of modern life. Unlike most other contemporary paintings, it was not based on a complacent liberal humanism, but on an awareness of the cultural and psychological fragmentation of the age. It fulfilled a deep need for an expressive art that gave full rein to subjectivity, and by its use of representational imagery demonstrated its involvement with real experience.

Also underlying this shift in intention and practice was a change in the perception of what was the most important twentieth-century art. Artists and critics became aware of work that didn't fit into the 'official' formalist history of painting as being a relatively straightforward progression from Cubism to Post-painterly Abstraction. The German Expressionists, especially Kirchner and Beckmann, assumed a new importance as models. So, too, did Picabia and de

3. Sandro Chia. *Genoa*. 1980. 226 × 396 cm. (89 × 156 in.) Private collection

Chirico, much of whose work had been denigrated as merely dandyish. Their self-conscious use of differing styles now seemed not arbitrary, but appropriate to the age. Their resistance to good taste was seen, like the Expressionists' resistance to the bourgeois world, as one to be adopted.

Likewise, there was a growing awareness of how many painters had, since the last war, put a premium on both expressiveness and the use of the figure. Francis Bacon, Balthus, Leon Golub, and the COBRA artists, especially Asger Jorn, all appeared as predecessors, if not models. Jackson Pollock's last difficult paintings and De Kooning's *Women* paintings of the early fifties could be seen as precedents, as could the later paintings of Picasso.

It must be emphasized, that although the majority of New Painters are young, there is a substantial group, including Baselitz and Lüpertz, which has been working in this way, albeit without any great international recognition, for at least two decades. There are also several older artists, Guston for example, whose work changed in later years to expressive figuration.

The painters one normally associates with the New Painting show figures and scenes from actual life, though often tangled with myth and dream. This is not done with the exact realism of traditional figurative painting, but with vigorous paint gestures: loose, fast painting – a technique normally associated with abstraction – applied to imagery from the real world and the subconscious. The *patois* of commercial illustration and fashion drawing seems more the progenitor of these figures than life drawing. This is, above all else, figurative art as made by artists with little or no training as figure painters.

In Sandro Chia's painting *Genoa* (Plate 3), two figures in baggy suits fly up into the sky as though relieved of all weight. In our dreams, the sensation of flying is normally associated with sexual desire, or with an escape from some restrictive situation. So it is here, and indeed such are the basic intentions of the New Painting. Chia also gives us images from our subconscious: their emergence into the conscious world of representation is a liberating one. Elsewhere, his figures glory in their physicality. They belch, urinate and break wind; they eat and run ceaselessly from place to place – much of the New Painting is concerned with extolling our physical experience of the world. But, above all else, the figures in Chia's paintings are seen painting. For Chia and for his figures, painting is *the* way to assert one's existence, to participate in the world.

Just as its showmanship and neglect of traditional craftsmanship antagonizes the many establishment critics of New Painting, so its exuberance and playfulness was bound to offend their sense of the seriousness and dignity of art, and likewise its effervescent commercial success. Sell-out shows of work by these artists and other young painters are common. At the same time as the young painter and tyro Julian Schnabel was being decried as an 'opportunist', an 'incompetent' and an 'invention of the media', his work was being bought and sold with reckless abandon (Plate 2).

For someone like Burgin, with his Marxist viewpoint, it all went to prove that such a resurgence of painting was no more than a result of market pressures

— an art dealer's *putsch* to sell anachronistic, expressionist revival pictures. For the American abstract painter and writer Walter Darby Bannard, it was all a conspiracy against good taste and truth:

> The market's problem is that there is never very much good art. As the market grows there is proportionally less good art and it becomes harder to convince the art public that the art on hand amounts to much. Therefore the market welcomes any attack on high standards which can be sufficiently rationalized. By demeaning high standards and anyone or anything which adheres to them, or even invokes them, and by reducing the Modernist from paragon to pariah,

4. Robert Rauschenberg. *Magician II*. 1961. Combine painting, 107 × 152 cm. (42 × 60 in.) Private collection

the New Art and Postmodernism hand the market what it wants and needs. What a relief not to have to worry about what's good! With that out of the way the market can get down to the very serious business of selling lots of very bad art for very high prices.

Though one may see Bannard's as the outraged and impotent voice of the *ancien regime* sailing into exile, he raises many essential points: we must come to terms with the New Painting's relationship with the market and understand its desire for effect before quality. Like all the best critics he illuminates as he insults, as when he berates the New Painting's emphasis on content:

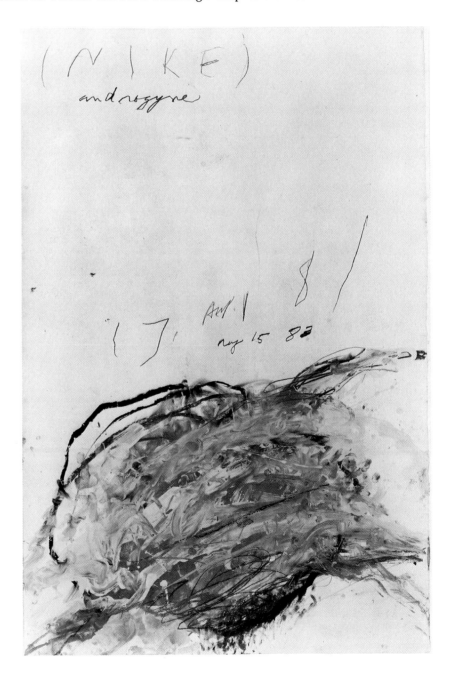

5. Cy Twombly. *(Nike) Androgyne*. 1981–3. Oil and wax crayon on paper, 104 × 70 cm. (41 × 27½ in.) Private collection

. . . for years I've seen that 'content' lying in wait, heavy-handed, student-level painting, rich in reds and blacks, a great seething, gravelly substratum of vaguely ominous, cartoon-derived, funky critters. In fifteen years of jurying, from Worcester to Washington, from Durham to Dallas, I have never, for example, juried a show which did not have at least one image of a menacing dog with long, sharp teeth. Now they are here in packs in the downtown galleries. Sometime late in the '70s, all this 'content', all this universally shared 'personal imagery', gathered itself up, like the Visigoths, and came to Rome.

As Bannard unwittingly seems to suggest, there was a need for a content-heavy art. The New Painting was, and is, the art naturally produced by its age.

But it is a more complex phenomenon than Bannard would have us believe. The very term 'New Painting' indicates the difficulty people have had in identifying and labelling it. Unlike the classic movements of art history such as Fauvism or Cubism, here there is no radical and specific stylistic or formal 'breakthrough'. Neo-expressionism, New Image, the Trans-avantgarde, *Figuration libre* – all have been used to describe it. The first suggests a revival of expressionism, which is no more than a quarter truth and certainly does not apply to such 'cool' artists as Salle or Alberola. The other three terms apply to very specific national movements, and are best left that way. As we are dealing with several parallel tendencies rather than a coherent group with a specific aim, we are, short of inventing a new term (Visigothic painting perhaps?), best left with the rather bland term, 'New Painting'.

Certainly the term 'Post-modernist' helps, if not in defining this painting, in locating its essential concerns. Generally, the philosophical and cultural debate around the notion of Post-modernism revolves on the opposition to Modernism's dogma of progress and on its insistence on the autonomy of disciplines: poetry, photography, painting, and so on. Beyond this, post-modernism focuses on two problems: firstly, on the death of the subject – the coherent and complete individual, dominating and directing his world; secondly, on the way the world exists only in representations – that we know reality only through those media (TV, language, pictures) that endlessly produce or *re*produce it for us.

Modernism had become too associated with American abstract painting, which had lost most of the excitement that the great Abstract Expressionists, Pollock and De Kooning, had given it in the early fifties. The decorations of New York painting became more and more diluted and narcissistic. The onus was increasingly upon the art critics to explain and validate these formal caprices – as it was for much of the art of the seventies other than painting. In an article written in 1979, American art critic Donald Kuspit claimed, with some justification, that the critic was now the artist: the act of signification lay with him, while the artist provided the illustrations to his arguments.

The reaction was inevitable. Painters turned to fashion, anti-intellectualism and, above all, 'gut-feeling' for approval and validation rather than to

6. Josef Beuys. *Trance in the House of the Shaman.* Pencil with collage, 18 × 16 cm. (7⅛ × 6¼ in.) Private collection

writers. It is symptomatic that big group exhibitions popularized New Painting – notably *The New Spirit in Painting* of 1981 and *Zeitgeist* of 1982 – rather than the writings of critics.

It has been claimed a similar reaction took place in the early sixties, with the emergence of artists such as Jasper Johns, Robert Rauschenberg and Cy Twombly, and subsequently Pop Art and Andy Warhol. Indeed, many would put the putative beginnings of Post-modernism with them. Certainly, the purity of the picture plane, the coherent artistic personality and all the other shibboleths of Modernism and romanticism were called into question by their work. Rauschenberg's assault on the picture was especially virulent – a bedspread covered in tackily-applied paint masqueraded as a canvas, while actual canvases had stuffed goats or eagles, electrical machinery or old tyres attached to them. In *Magician II* (Plate 4), a typical work of this period, he fastened a variety of rusty wires and springs and a tatty collection of old fabrics to an apparently crudely painted canvas: the detritus of an industrial culture was turned into art.

This use of materials has had its influence on New Painters, but if we look at Kiefer's straw and wood, Schnabel's antlers and broken plates or Cucchi's branches, we see that they have *transformed* their materials far more. Likewise if Warhol's novelty was in introducing the mass media imagery of film stills and newspaper photography into painting, it was very much as one commenting on something new, much as an eighteenth-centrury artist might include a hot-air balloon in a landscape. In contrast, the artist Kenny Scharf, born in Los Angeles in 1958, was brought up on TV, and uses imagery culled from it as naturally as from the outside world. Yet Warhol's denial of the personal language or style that was, as it were, the trademark of an artist, has allowed later artists, like David Salle and Sigmar Polke, to deal with a world from which they felt alienated with a new irony.

Rauschenberg's contemporary, Twombly, has been a seminal figure for younger artists like Francesco Clemente in the last few years. After a trip around the Mediterranean with Rauschenberg, he stayed behind in 1953 and married a member of the Rome aristocracy. Through this, and through natural inclination, his work has become an evocation of European culture, especially of places like the bay of Naples where Greek, Roman and Renaissance civilizations met.

But above all else, Twombly's work depended on drawing. Once, endless calligraphy filled his canvases as though he was ceaselessly practising his signature; or else a mess of graffiti, writing and splotches of colour would cross them. But the deceptive scruffiness of his work was a way of evading the decorativeness that can afflict abstract art so easily. His art is at once sensual and intellectual. For all its 'Modern' techniques, his references are to Greco-Roman and Italian culture. To situate an art, that seems so extremely modern and also on first acquaintance so difficult, within a traditional European culture, has been a crucial precedent for many artists, especially in Italy.

In recent years, Twombly has made few pictures, producing occasional small paintings or collages that combine classical references with areas of impastoed paint scrawled over with crayon. Typical is *(Nike) Androgyne* (Plate 5). What connection there is between the Greek goddess of victory and the areas of grey-white paint and black and red pastel is not easily analysed. What is obvious is the poetic, allusive quality and the persistent sense of subliminal sexuality.

If Twombly's work at times seemed private, that of the German artist Josef Beuys was the result of a conscious attempt to reach a mass audience. Even if it were only as the most charismatic teacher of art since the war – one who has numbered among his students Walter Dahn, Jorg Immendorff and Anselm Kiefer – we would have to take note of him. But his influence as an artist has also been enormous. In 1943 he was the pilot of a Stuka dive bomber on the eastern front. Shot down by flak, he was recovered from the wreckage of his plane by Crimean Tartars who covered him in fat to help him regenerate warmth, and then wrapped him in felt for insulation. The fat and felt have since become key elements in his sculpture, emblematic of a return to a more instinctual relationship with nature and the world of animals.

Beuys's art is frankly utopian. He believes it will lead to a better world, a transformed society based on the creativity of each individual. At the root of this transformation, or redemption, lies an acceptance of the physical world as being more than inert scientific fact. To Beuys, art shows the spiritual energy in material things, as he said, 'it is the transformation of substances that is my concern in art, rather than the traditional aesthetic understanding of beautiful appearances. That is precisely what the shaman does in order to bring about change and development: his nature is therapeutic.' The artist becomes the shaman for this fragmented society. For Beuys the spiritual poverty of this age, with its historical traumas, constitute a collective wound, which art alone can heal by taking man and woman back to their real being in the world, where they live in natural and creative harmony with animals and the forces of nature.

Apart from his influence as a teacher and as a model for the artist, Beuys is important, like Twombly, for the stress he has put on drawing (Plate 6). It is through drawing that the subconscious most easily speaks, where elements from autobiography, myth and history may meet and combine.

As often happens with a period of doubt or change, there is now an obsession with the artist's role and self-image. The model for the spate of self-portraits in the New Painting does not seem to be so much Rembrandt or Van Gogh, with their long series of self-analyses, as it is de Chirico, the Italian artist who throughout his long life painted innumerable portraits of himself in different roles and masks (just as in his late paintings he would adopt different styles). In a period when the credibility of the unique and heroic personality is so in doubt, the mask of the stylist is an appealing manner with which to face the world.

No artist uses his own image more than Francesco Clemente. Throughout his paintings and drawings, his face appears as a constant, a point of anchorage for his imaginings and reflections. But always he is not so much the actor in his pictures as the person to whom things happen – a bird walks up to him and put its beak in his mouth, chameleons whisper in his ear, a shrew climbs from his mouth (Plate 7).

Likewise, the face of the Cologne artist Jiri Georg Dokoupil is something to which things happen. In the 1984 series *Self-portraits with Nose Bleed* (Plate 8), blood pours from his nostrils and eyes like badly applied make-up and a flower climbs from his brain and wilts. The face has become the stage for the dramas of the subconscious and the imagination. In one of an important series of collaborative works with Walter Dahn, an enormous snake coils around the screaming faces of the two artists, whilst above them the moon is about to be eclipsed (Plate 9).

But if one trend of the New Painting is towards a release of the imagination and the irrational, another trend is towards an acute realism, a depiction of things not normally spoken, nor represented. The paintings of Eric Fischl can embarrass the viewer with their frank, even voyeuristic treatment of sex, as can Salomé's pictures of homosexual orgies. Werner Büttner's *Self-portrait masturbating in the Cinema* (Plate 10) is the most unpleasant of all

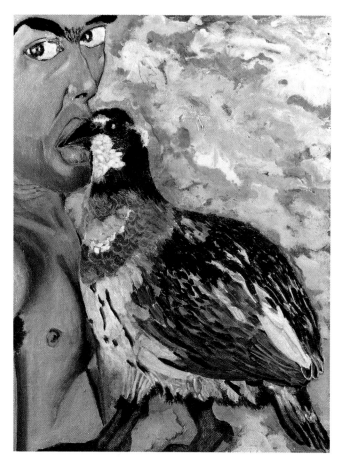

7. Francesco Clemente. *Self-portrait with Bird*. 1980. Oil on canvas, 40 × 27 cm. (16 × 10½ in.) Private collection

8. Jiri Georg Dokoupil. *Nose-bleeding Self-portrait No. IX*. 1984. Water-colour on paper, 55 × 35 cm. (21½ × 14 in.) Private collection

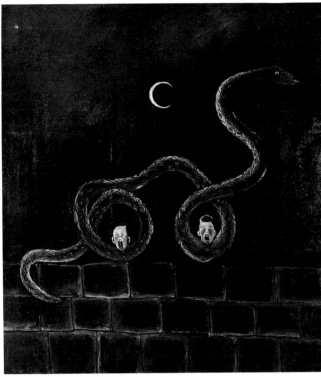

9. Walter Dahn and Jiri Georg
Dokoupil. *Untitled*. 1984.
Dispersion on cotton,
200 × 180 cm. (79 × 70 in.)
Private collection

10. Werner Büttner. *Self-
portrait masturbating in the
Cinema*. 1981. Dispersion on
cotton, 150 × 115 cm.
(59 × 45½ in.) Private collection

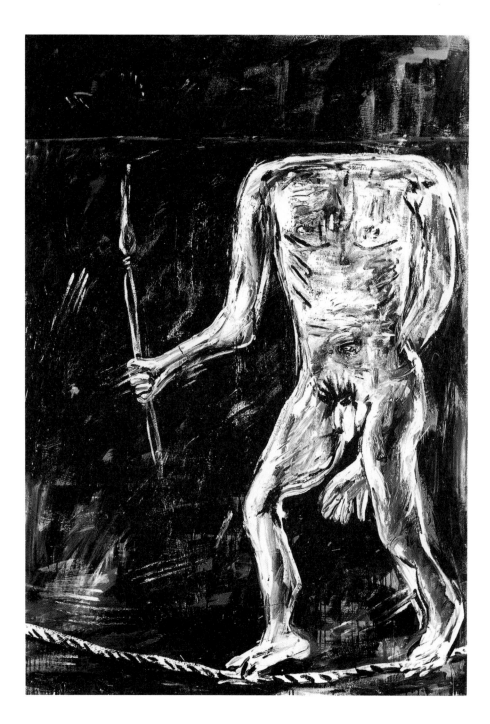

11. Walter Dahn. *The Painter (in Search of the Icon of the Twentieth Century).* 1983. Dispersion on canvas, 210 × 150 cm. (83 × 59 in.) Private collection

recent self-portraits. For him, at least, the artist is not a 'pure spirit' removed from life, but someone engaged with even its most tawdry and seamy aspects.

One of the most telling self-portraits is Walter Dahn's *The Painter (in Search of the Icon of the Twentieth Century)* (Plate 11) in which the artist has actually lost his head and face. Paintbrush in hand, he walks a tightrope in the blackness of night. In searching for the icon of this century – that image we can relate to as other centuries have related to the face of the Madonna or Christ – is he seeking his own head, his own identity? He is naked, lost in an existential wilderness. What does he have left but the base line of his own body and its functions?

2 ━━━━━ SPEAKING IN GERMAN AGAIN

I am in Pandemonium undergoing hygenic solace.

George Baselitz

In *The Tree* (Plate 14), painted by Baselitz in 1966, a tree stands leafless and bandaged. The large branch on the right has been lopped off and drops of blood fall amongst other broken branches on the blood-spattered ground. In front of the tree, hanging from a rope strung between two poles, is a butcher's hook with a bloody string of entrails caught on it. Behind, and to either side of, the tree stand a disused plough and a bicycle. These, and a second string of entrails, are coarsely scrawled and the whole is painted in a chunky, diagrammatic manner in red, verdigris and black. This bleak and unpleasant image is presented with a deliberate lack of grace, yet the unpleasantness is not vicarious, but part of a moral vision of a discredited world. All is ill with the state of Nature: the tree is broken and bloody; the plough lies discarded in deserted and barren fields; the city dweller with his bicycle will find no pastoral elegy here.

Baselitz was born George Kern in 1938, in Deutschbaselitz, a town now in East Germany. He was expelled from the art academy of East Berlin for 'political immaturity' and moved in 1957 to West Berlin, where he adopted the name of his birthplace. At that time, the guilt of being German was such that traditional German styles of expressionism had been eschewed in favour of the most sanitized and academic types of international abstract art, which then seemed the style of world democracy. Baselitz's work was directed against this and against the complacency of Adenauer's Germany. Just as Germany had denied its past because of the hideous crimes of fascism, so it had denied the power of the subconscious and of the emotions.

Against the superficial art of the academy, Baselitz presented an aggressive figurative art based on the insights of the irrational, the mannerists, the mad. Accompanying his first exhibitions in 1961 and 1962 were long diatribes of excess:

We have blasphemy on our side! In my eyes can be seen the altar of Nature, the sacrifice of flesh, bits of food in the drain, evaporation from the bedclothes,

12. Georg Baselitz. *Red Bird*. 1972. Oil on canvas, 162 × 130 cm. (64 × 51 in.) Private collection

13. Georg Baselitz. *The Brücke Choir*. 1983. Oil on canvas, 280 × 450 cm. (110 × 177 in.) Private collection

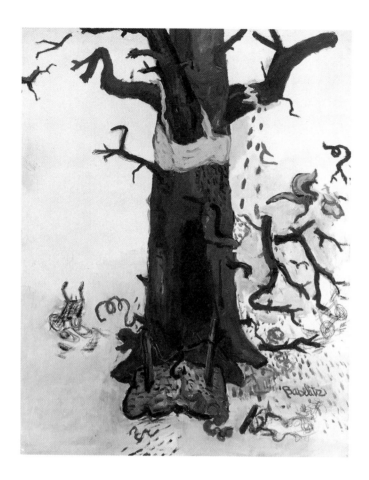

14. Georg Baselitz. *The Tree.*
1966. Oil on canvas,
162 × 130 cm. (64 × 51 in.)
Private collection

bleeding from stumps and aerial roots . . . With solemn obsessiveness, radical gestures – we want to excavate ourselves, abandon ourselves irrevocably . . . We live through endless ecstasy. My secret. Paranoia on paranoia . . . I am in Pandemonium undergoing hygenic solace.

Two paintings were confiscated by the police from a 1963 exhibition because of their supposed obscenity. It was, however, more than the subject matter, the very activity of painting that Baselitz saw as both destructive and redeeming. If we look at a painting of this period, *The Hand of God* (Plate 28), we see an extraordinary image: a vast hand in space with a house, a plough and a spade resting on it and above that three crows. Though our attention is initially gained by this image of God – holding out not profound destiny but the odds and ends of ordinary life – it is the facture and colour that affects us emotionally: the meaty reds and blacks of the hand, the scumbled yellows, greys and pinks of the background field. It is a standard strategy with Baselitz and other artists associated with the New Painting to pin us down frontally with a motif and then attack our unsuspecting flanks with the emotional charge of the painted field.

Ultimately, these strong images became insufficient for Baselitz. He wanted to subvert the represented world even further, thereby drawing attention to the very fact of painting. His first tactic was to draw a line across the canvas, fracturing the image so that top and bottom would be unaligned. By 1969, this evolved into the straightforward procedure of painting each picture

upside down, a technique he has continued with ever since. (It is important to realize that they are painted upside down – not turned upside down afterwards.)

There is a paradox here. While Baselitz may say that his aim is to draw attention away from the image as representation, to 'the image as a painting' (a shock tactic that is often compounded by hanging the paintings well above head height) we nevertheless still read them as figures – we turn them back the 'right' way in our heads.

Often, Baselitz seems to be reasserting old truths in new forms, as with much painting of the seventies which used landscape or natural imagery as a starting point for paintings of great lyrical beauty. The painting *Red Bird* (Plate 12) may well be a parody of the 'pretty' wildlife we see in greetings cards. But it is also a painting of such abstract beauty – with the reds balanced against blues, highlighted by white, the whole made alive with vigorous brushmarks – that we can sense a cleansing of the cliché-ridden spirit. Images that are stale from over-use are made fresh and new.

Above all else, Baselitz's subject is the human figure, and especially the figure divorced from its customary setting. Most work of the eighties shows archetypal figures painted with swathes of bright, unnatural colours swimming

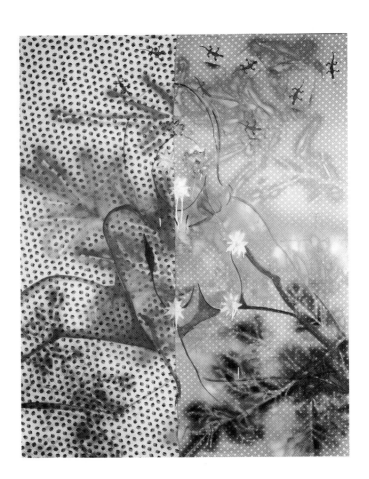

15. Sigmar Polke. *Nude with Salamanders*. 1971.
Dispersion and spray paint on printed textiles, 180 × 150 cm. (71 × 59 in.) Private collection

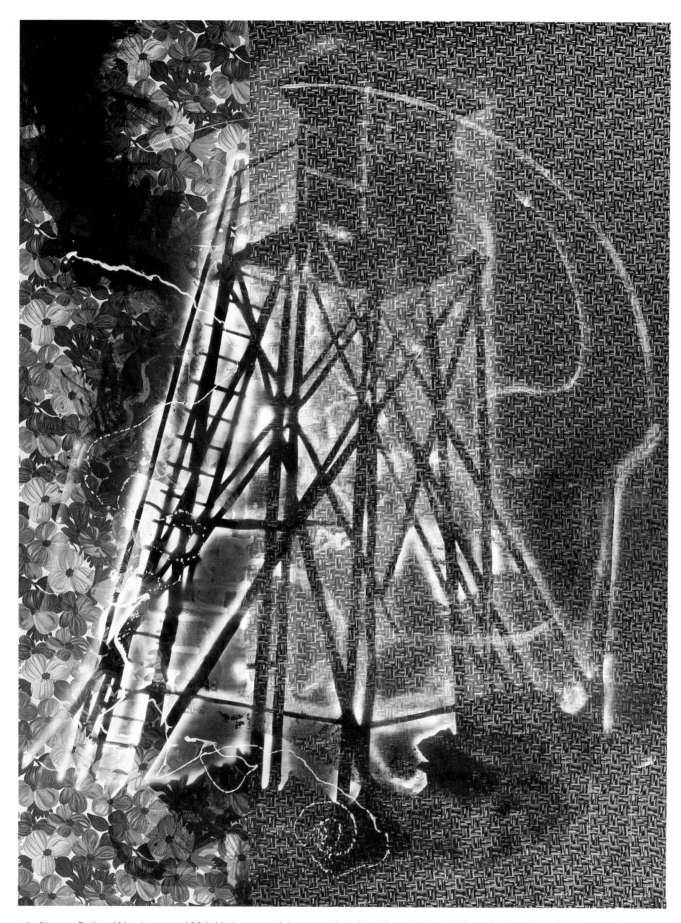

16. Sigmar Polke. *Watchtower*. 1984. Various varnishes on printed textiles, 300 × 223 cm. (118 × 90 in.) Private collection

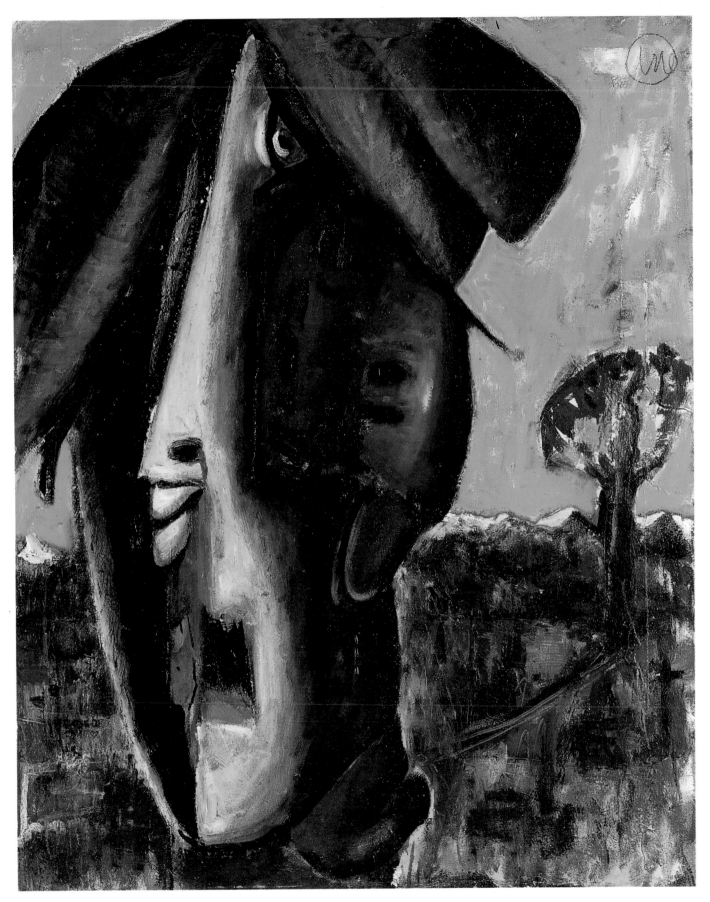

17. Markus Lüpertz. *Alice in Wonderland: 'You don't know much,' replied the duchess.* 1981. Oil on canvas, 100 × 81 cm. (39½ × 32 in.) Private collection

in a sea of undifferentiated paint. More and more, Baselitz wanted to conjure forth the presence of a free and independent human being – a figure of resistance much as his art has been one of resistance.

Recent paintings, such as *The Brücke Choir* (Plate 13) are at once more abstract in their colouring and drawing, and yet more complex in their overt subject matter. There is a growing sense of both tragedy and ecstacy in these wide-mouthed faces. The singers are those painters Kirchner, Heckel *et al.*, who made up the expressionist group the *Brücke*, and who pre-figure Baselitz in his struggle. They sing, presumably as stridently as they are painted. What they sing is unknown; it is the act of singing that is crucial.

If Baselitz provides one model for the artist in a Post-modernist society, Sigmar Polke, three years his junior, provides a very different one. Where Baselitz's art is essentially tragic, committed to a notion of truth, Polke's is comic, denying the possibility of any ultimate truth. 'Who is Sigmar Polke?' once asked an article, for Polke declines to have a single autographic style. He sees the world as a multitude of simultaneous languages constructed by conflicting styles and media. It is this that he represents in his art.

Polke's work developed out of the Pop-influenced paintings he made in the sixties, together with the older and more austere artist Gerhard Richter. Richter went on to systematically analyse what painting was and its differences from photography. Likewise, Polke's interest has always been not so much with the images of the mass media *per se*, as with the way in which they endlessly reprocess themselves. But Polke is never systematic: at times his choice of both imagery and style of painting seems wilfully arbitrary. There is a playfulness in his attitude to picture making, as though he would deny himself anything but fitful control of his pictures. As he once said, 'I can't paint. I can only live in pictures. The painting gets done automatically.'

In part, this is disingenuous. Polke can and has painted and drawn well in relatively traditional ways. But he chooses not to do so, declining mastery of his material. In a not untypical painting of 1971, *Nude with Salamanders* (Plate 15), a big-breasted woman (copied from a pornographic magazine) is drawn on

18. Markus Lüpertz. *Apocalypse – dithyramb.* 1973. Distemper on canvas, 260 × 730 cm. (102 × 283 in.) Private collection

commercial fabrics; stencilled salamanders and leaf-like patterns of spray paint sprawl across her, while star-shaped blobs of paint mimic sequins on her nipples with deliberate ineptitude. On one level, Polke seems to be commenting on the vulgarity of the mass media; on another, denying Art's efficacy to do anything about it. What is never in doubt is his ability to bring together disparate elements with immense verve and elegance.

In recent paintings, Polke has absented himself and his 'artistic signature' still further, for there is little painting as such in them: images are projected onto photographically sensitive materials, which are themselves brushed around and complemented by casually applied areas of paint. Some of these works, for example, *Watchtower* (Plate 16) of 1984, are marked by a curious transient beauty. It is a transience, moreover, that is encapsulated in the very chemistry of these 'paintings', for with their use of silver nitrates, bromides and other photo-sensitive materials they change colour radically under different lights. But despite all the decorative delights of surface and colour and the humour of many of the colliding images, Polke's art creates very real problems of understanding. These are all related to his quizzical denial of an artistic personality and the moral implications of this missing point of view. Here, for example, where the watchtower is shorn of context and meaning, one must ask: is it from a border or a concentration camp?

Behind the beauty and wit of Polke's pictures lie an incompleteness that he sees as mirroring this age. He will not give us the traditional satisfactions of the coherent and homogenous picture. Indeed he would argue that such satisfactions are now a deceit. Against the lost morality of old ways of seeing, Polke offers only the energy and elegance of his play with materials and images of the world.

For Polke, the great virtue of painting is its ability to distance the world from us; for Baselitz the opposite. Where Baselitz searches for images from the subconscious, Polke seems to deny their existence. Both are reacting against a world they despise, but they move in opposite directions. Where Baselitz would reform it, Polke is content to laugh and play (albeit serious) games with it.

The wit and apparent levity of Polke's work has made it especially attractive to a younger generation of artists, but most of his own generation are more sober, even consciously tragic, in their attitudes. Of no one is this more true than Markus Lüpertz. His work of the sixties centred on the use of what he termed a dithyramb, a coherent and large motif symbolic of psychic wholeness. For Lüpertz, the painting and contemplation of these motifs could lead to ecstasy, an awareness of reality beyond everyday banality. The artist, as he indicates in a poem of 1973, is akin to a prophet: 'be resigned to me, there is no other way, there is no defence against me, I am like the rain, I bring the flowers to bloom in you, the earth to life, I make the world bearable to you, be glad, for the fear is mine.'

Initially, these dithyrambs were large abstract shapes hovering in the sky like pieces of machinery masquerading as angels of the annunciation. But as they developed, they began to echo the real world more, as in the enormous

19. Jorg Immendorff. *Café Deutschland, shake/raise*. 1984. Oil on canvas, 285 × 330 cm. (112 × 130 in.) Private collection

Apocalypse – dithyramb (Plate 18) of 1973 in which a shell-shape is repeated over three canvases. In the centre panel it is joined by a homburg hat and coal-scuttle helmet, both of which have traditional German associations. Lüpertz's intention is not to glorify these images, but to show them emptied of meaning in the face of the dynamic force of painting. His use of such imagery is often ironic: the helmet refers to an occasion when, walking along the road in Italy, he saw an old German helmet lying discarded at the verge. The inappropriateness of it there appealed to him. Indeed, the comedy of a world where objects have lost their name and function was to become typical of much of New Painting.

In the last ten years, Lüpertz's work has become more unplanned, more improvised. His paintings often seem scuffed and stained, unfinished. This is part of the message, that these are not coherent statements, but raids on the inarticulate. Their results are no more than provisional. Lüpertz himself is little concerned sometimes with the final presentation of a work, leaving his assistant to stretch up the canvas and make final decisions about cropping – an attitude

21. Jorg Immendorff. *Café Deutschland I*. 1978. Acrylic on canvas, 282 × 320 cm. (111 × 126 in.) Aachen, Ludwig Collection

22. Jorg Immendorff. *Self-portrait*. 1980. Acrylic on canvas, 150 × 150 cm. (59 × 59 in.) Private collection

shared by many German artists. Their emphasis is more on the activity of painting than on its results.

With Lüpertz's free-wheeling approach, all things can be the starting point for a painting. His reading of Lewis Carrol's *Alice in Wonderland* led to a series of forty-eight panels that vary from outright abstraction to a figuration as dislocated as Carrol's narrative. Typical is the image of the Duchess, where she is part nose-bleeding head and part sculpture (Plate 17). It is the vitality of the painted forms that is essential here, not the narrative which merely provides the occasion for them.

The intentions of A.R. Penck and Jorg Immendorff are far less inscrutable, though they do share with Lüpertz a utopian belief in the power of art to change people's ideas and the world. Penck was born in Dresden in 1939; Immendorff six years later near Luneberg, just the other side of what would become the border of divided Germany. For both of them, that division has become not only a political and cultural disaster, but a symbol of a deeper division in the human psyche – the alienation of man from his instinctive feelings.

In Immendorff's painting *Café Deutschland I* (Plate 21), the artist himself faces us in the centre of the picture, his hand breaking through a wall towards Penck, whose bearded reflection we see in the pillar. Like Immendorff,

23. Anselm Kiefer. *The Artist's Studio*. 1983. Oil, emulsion, woodcut, shellac, latex and straw on canvas, 280 × 280 cm. (110 × 110 in.) Private collection

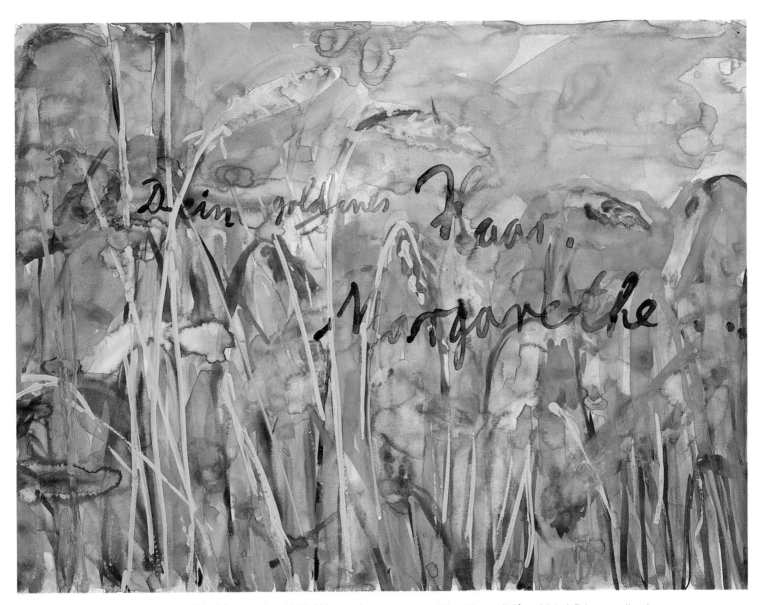

24. Anselm Kiefer. *Your Golden Hair, Margarethe*. 1981. Watercolour on paper, 42 × 56 cm. (16½ × 22 in.) Private collection

he wields a paintbrush. Like their friendship, art will break down the barriers created by politics and ideology.

The various *Café Deutschland* (Plate 19) paintings, in which German society is equated with the inhabitants of a nightclub or bar, allowed Immendorff to make vivid and complex pictures of his world in which history, myth and autobiography are mixed. Once a political activist and follower of Beuys, and although he still owes allegiance to the Green party, he has become more a commentator on society than a participant in its struggles. Like many other artists, he has been thrown back on his own resources and forced to establish his beliefs from them. In a self-portrait of 1980 (Plate 22) we see him in his studio pausing from work, smoking a cigarette, all around him the undifferentiated marks of gestural abstraction. Before his right eye, an eagle (that traditional symbol of German nationalism, and also smoking a cigarette) is beginning to materialize. Another such form is materializing on his T-shirt. For Immendorff, the activity of painting, which for him makes sense of inchoate matter, is linked with fighting the ideology of one's upbringing: the moment one pauses, the preconceptions of one's culture re-emerge, just as the eagles do in the picture.

Immendorff's combination of loose painting with socio-political commentary is unique and far different from the Socialist Realism to which he briefly subscribed. However, his work is most often successful when his painting is least encumbered by a symbolism that can become impenetrable, especially for the non-German.

The symbolism in A.R. Penck's work is more generalized. When asked for his response to a critic who called his work 'incomprehensible', he replied,

> . . . in a way he is correct. I think I would even underline that. If it were different then the interest would quickly disappear. Mystery, coding, is essential. Once you have crossed the threshold of naivety that coding process starts automatically.

Like the apparent ravings of the priestess at Delphi, Penck's paintings cannot be analysed logically. Their meaning must be sensed.

N– Complex (Plate 20) is representative of Penck's work. Shapes and figures transform themselves violently: the breasts of a red woman become heads, a diagram becomes an octopus with a tentacle-come-hand that touches her. This is a picture of life at an almost primeval level where things are in constant flux and where one object will become another. Whether we are supposed to see the red woman as a Kali-like goddess of vengeance is never clear. On the whole, Penck's characters appear to be innocent spirits; where there is violence, it is Dionysian frenzy rather than destructiveness. Of course, his work deliberately exploits its 'primitive' look, its echoes of graffiti and bushman art, but it should not blind us to the sophistication with which he distributes elements across the canvas.

Until 1980, Penck stayed in East Germany, where he was forbidden to exhibit, and forced to show his work in the West under an assumed name (his

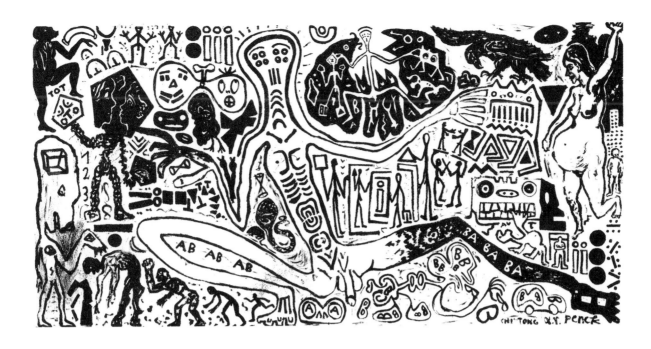

25. A.R. Penck. *Chi Tong.*
1982. Acrylic on canvas,
500 × 1000 cm. (197 × 394 in.)
Private collection

real name is Ralf Wingler). He was then forced to emigrate to the West. Since then it seems that work has lost much of its edge – the primitivism appears more calculated; the sensation of improvising under constant pressure has been lost. However, a painting like *Chi Tong* (Plate 25) still shows his profligate imagination at its best with its fluent line, its different types of figures and its dynamic, if strangely decorative, composition.

Penck, Baselitz and Polke are all exiles from East Germany; Lüpertz fled with his parents from Bohemia when he was eight. For all their generation, the division of Germany was the traumatic event of their childhood. It is this sense of loss and incompleteness, together with the repressed history of Germany, which Anselm Kiefer takes as his subject.

In his 1971 painting, *Man in a wood*, Kiefer portrayed himself as a penitent dressed in a white shift, a blazing branch in his hand; behind are the fir trees of the archetypal German forest. When asked why he had not just painted the wood without this curious figure, his reply was, 'You cannot just paint a landscape after tanks have passed through it. You have to do something with it.' The landscape is no longer innocent. It, and pictures of it, have been defiled by historical associations. For Kiefer, the artist must represent the landscape *with* those associations exposed and in so doing release it from their restrictions. The burning branch is symbolic: the artist's imagination, like fire, can transform our world, and our experience of it.

Kiefer's intention is not only to expose those elements of German culture which have been repressed by post-war capitalist society. He also wants to reclaim the instinctual feeling for the physical world that children have. In his large paintings, he uses the most extraordinary conglomerations of materials: acrylic, emulsion and oil paints are tangled with straw, sand and shellac (a form of black lacquer), all spread across canvases partly covered by rucked and rumpled sheets of photographic paper. On to these heavily laden pictures, lead

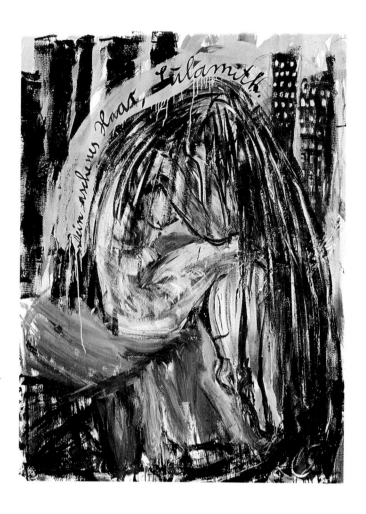

26. Anselm Kiefer. *Your Ashen Hair, Shulamith.* 1981. Oil on canvas, 170 × 130 cm. (70 × 51 in.) Private collection

wings or ladders, encrustations of dried clay or racks of rusty implements might be hung. It is the sliminess, tackiness and dereliction of his materials that one responds to rather than to qualities of fine brushwork: the textures and sculptural nature of the work both attract and repell us.

In these often sombre pictures, landscape is the site of meaning and identity. It is noticeable, that since 1971 Kiefer has rarely painted a figure in his landscapes, in preference, drawing them emblematically or writing a name across the canvas. It is as though the artist must remake the landscape before he can paint figures in it. A typical emblem for himself, or the creative individual, is that used in *The Artist's Studio* (Plate 23), where a woodcut of a bunker-like studio is stuck in the middle of the familiar Kiefer soup of oil paint, shellac, latex and straw. The building, like the philosopher or artist, asserts its individuality against the chaos of the world and in so doing begins to give it order.

Against the deep seriousness of Kiefer's large paintings, we should set his more personal and lyrical paintings and water-colours. Some of the most poignant of these have been occasioned by Paul Celan's poem *Todesfuge (The Fugue of Death)* (Plates 24, 26), an elegy by the Jewish Roumanian writer for all that died in the concentration camps. In the poem, in an allusive and indirect way, the writer's two lovers, golden-haired, German Margarete and ashen-haired, Jewish Shulamith, become as one, both victims of 'Death . . . the master from Germany'. Like the poem, Kiefer's paintings are at once atonements of

collective guilt and rhapsodies to love and beauty. And just as Kiefer will always see history in terms of landscape, so here the golden hair of Margarete becomes golden corn and Shulamith's hair the ashes of the stubble. The two are one – in destroying the Jews, German culture destroyed part of itself. Elsewhere, Shulamith is seen mourning in front of gutted buildings – even the victim mourns what has been lost.

Despite his high reputation as an artist, Kiefer has no obvious followers. Indeed, his concerns seem very different from those of the younger artists. Whereas those of Baselitz's generation have grown up in a post-war cultural wasteland, the generation after have grown up in an Americanized society. Where the older artists see their alienation as tragic, the younger see it as comic. They do not seek redemption. There is often a frenetic quality to their work as if sheer energy and funkiness will provide sufficient release.

If we compare Walter Dahn's ironically titled *Baselitz – Pop* (Plate 27) with its model, Baselitz's *The Hand of God* (Plate 28), we see that his image has been vulgarized into that of a severed hand with a suburban building on it. Baselitz's subtle background of colours has been replaced by blotches of violet spray paint. The pun on 'Pop' says it all: Baselitz the humorous father figure, whose art has been transformed into funk.

It is not that the younger artists are not serious, but they cannot cast themselves as romantic outsiders in the way Baselitz or Lüpertz have. Although they may, rather self-consciously, put themselves forward as victims of society, they make the most of its opportunities. At a very early age, many had begun to sell a large amount of work, for the eighties have seen a boom in the purchase of contemporary paintings in Germany. Suddenly, painting had become fashionable. With its publicity-seeking, all-night parties, quickly-evaporating reputations and groupies, the German art scene is curiously like the rock music scene. Artists not only behave and dress like rock stars but may even adopt, like Salomé, stage names. The atmosphere of transience, vibrant energy and easily-earned money is common to both milieu.

The combination of wealth, *angst* and the sense of repressed imagination have combined in West Germany to make it the place where New Painting most easily and naturally developed. This is especially true of West Berlin where, with its hectic night-life and geographical isolation, there is a sense of living on borrowed time – for, as everyone knows, when the next war comes West Berlin will be overrun in the first few hours.

In 1980, the exhibition *Heftige Malerei* (Violent Painting) gave a name to a group of painters, including Rainer Fetting, Helmut Middendorf and Salomé, who were then in their late twenties. The expressionist painters had been especially connected with Berlin, and these painters consciously followed them, particularly in the way they responded to the alienation of city life with an accentuation on subjectivity, sharp colours and jagged drawing.

In many of his pictures, Middendorf used the image of the discothèque as a symbol of Berlin. His figures dance the night away, each living in his own world, each de-personalized as if already in Limbo. Desperation and ecstasy are

27. Walter Dahn. *Baselitz – Pop*. 1984. Spray paint on canvas, 250 × 150 cm. (98 × 59 in.) Private collection

combined, the normal bonds that join people together have been destroyed and they seem unable to touch each other (Plate 31).

Middendorf's other identity as a rock musician is reflected in his frequent choice of the rock singer or guitarist as his subject. His paintings share their excitement, portraying the same loss of inhibitions that one may have in the small, noise-filled rooms of rock music clubs. Long, sweeping brushmarks and an emphasis on unmixed colours are hallmarks of his and other *Heftige Malerei* paintings – a style accentuated by their use of dispersion, a form of quick drying powder paint. Like other *Heftige Malerei* paintings, these are often about identification and the projection of one's personality into a situation. In his self-portraits, Middendorf has often pictured himself posed in a frenzy in his studio, his brush held like a singer's microphone. This is an art of impromtu urgency rather than subtlety.

Salomé has also been involved in rock music, as well as performance art. When he took up painting in the mid-seventies, it was primarily to celebrate his

homosexuality. His early paintings were explicit portrayals of gay nightclubs and orgies. The excitement of presenting what had not previously been shown meant that they were painted with a fervour and conviction that compensated for their lack of technical guile.

Often Salomé's paintings were direct results of his performances, which had a strong exhibitionist tone. For their *Wild Boys* and *Tightrope* paintings (Plate 32), he and his boyfriend Luciano Castelli projected photographic slides of themselves cavorting on tightropes onto the canvas, then filled in the outlines with fast, decorative brushstrokes. Indeed, it is in vibrant decoration that Salomé's real talent seems to lie, as seen in his Sumo wrestler paintings (Plate 29).

It is true to say of all these Berlin painters that though their work can be mesmerically effective, it can easily degenerate into the predictable and repetitious; into radical chic wallpaper. One could draw a parallel with the decline of rock music into disco music, a form of aural wallpaper.

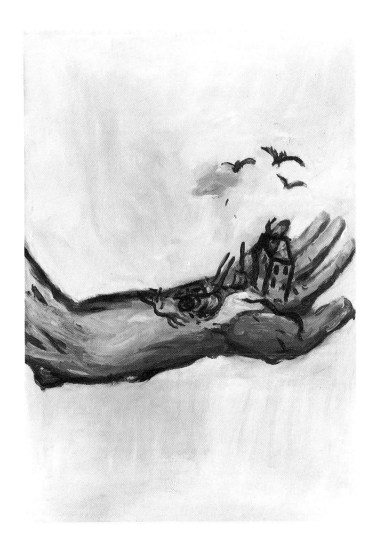

28. Georg Baselitz. *The Hand of God*. 1964/5. Oil on canvas, 140 × 99 cm. (55 × 39 in.) Private collection

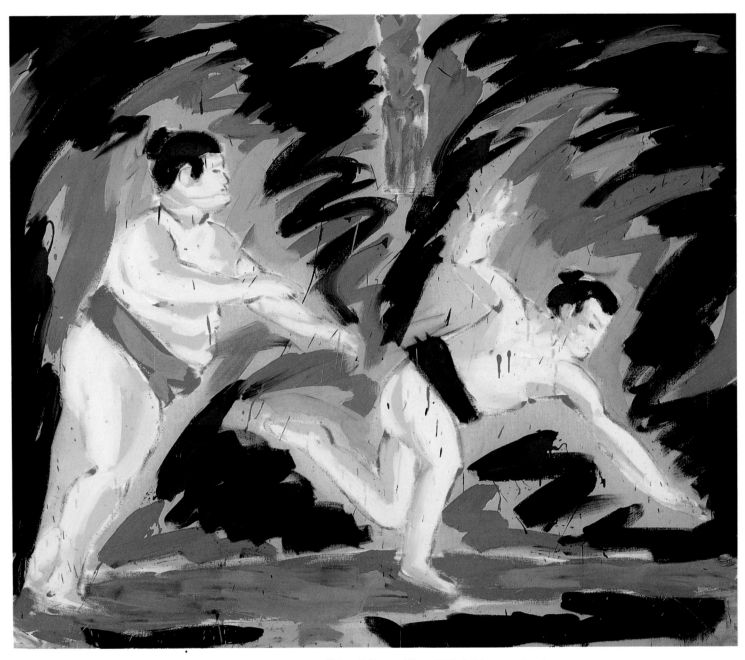

29. Salomé. *Sumo Wrestlers*. 1982. Oil-pigment on canvas, 200 × 240 cm. (79 × 94 in.) Private collection

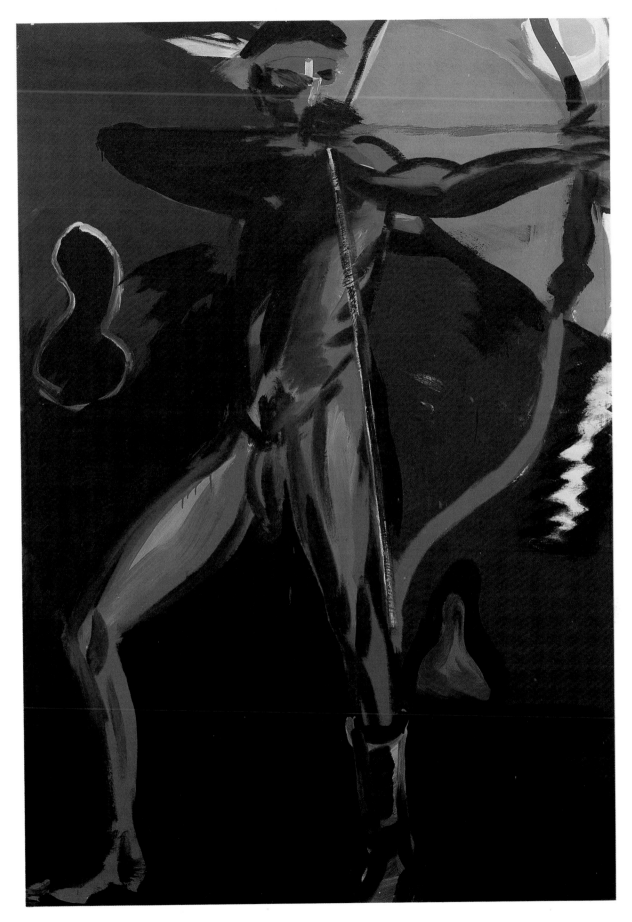

30. Rainer Fetting. *Indian II*. 1981. Dispersion on cotton, 250 × 170 cm. (99 × 67 in.) Private collection

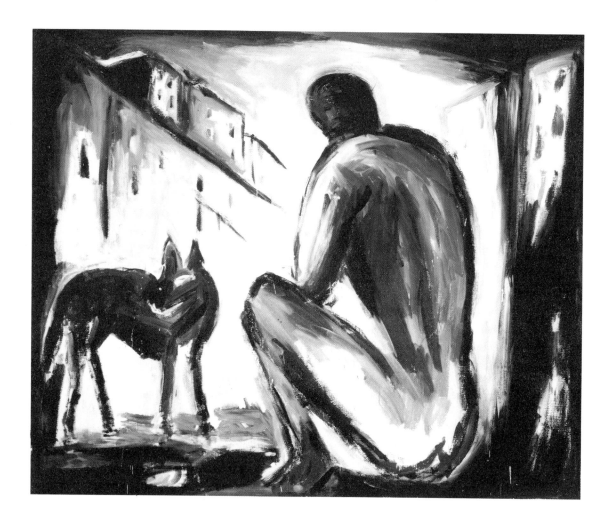

31. Helmut Middendorf. *The Dog Picture*. 1983. Acrylic on canvas, 180 × 220 cm. (71 × 87 in.) Private collection

Fetting, who like Salomé is openly gay, is less concerned with the exhibitionism of performing and more with the fascination of looking. His celebrations of his desires are more conventionally erotic, less intended to shock. In his best paintings, his achievement is to have gone beyond the ethos of beefcake and toward creating a set of poses for men which presents them as sexually desirable objects without denying their personality. For Fetting, the artist now lives in a socially constructed world where his instinctual life has been made to seem archaic. But in the gay scene, Fetting and his friends can dress up as Indians or gangsters. Their play-acting is deeply serious: primitivism, lust and heroism; all the strong emotions that cannot naturally emerge in everyday life can be expressed in these masquerades. Their paintings, like his *Indian II* (Plate 30) with its simple, forthright colour and powerful graphic design, monumentalize those emotions.

Such roles and models from fiction and art are important to Fetting because it is through them that the 'real' person can emerge. In 1982, when he imitated Velazquez's *Rokeby Venus* in his *Nude* (Plate 35), it was not from any laziness, but in order to replay the myth of Narcissus in contemporary terms and thereby reclaim 'naturalness' and elegance for the male nude.

Dieter Hacker, formerly a conceptual artist, rejects this new German expressionism with, as he terms it, its 'uncritical trust in power of the

individual'. To him, as to many on the political left, this reeks of neo-fascism. For Hacker, painting is not about a 'new ecstasy' but about traditional humanist values. As he says, 'in an age devoted to the love of things big, it points to a more human dimension. Surrounded by alienation, it celebrates the idea of fulfilment'.

Although his paintings do not look radically dissimilar to some *Heftige Malerei* pictures, they have more modest, lyrical subjects and are meant to evoke reverie and contemplation. When he paints, as in *Red Earth* (Plate 33), a vast sleeping red woman, it is not only (with its reference to the nudes of Matisse) an image of feminine beauty but also an image of latent power. Given its colour and Hacker's beliefs, it is possibly an image of the proletariat as well, sleeping but still powerful.

Most Berlin painters, however, are more interested in images of trauma than of beauty and dignity. Painters such as Elvira Bach, Thomas Lange, Ina Barfuss and her husband Thomas Wachweger followed on the initial impetus of *Heftige Malerei*. Another group of painters, the 'metaphysicals' – of whom Peter Chevalier is the best known – create strangely melancholic pictures of empty, silent cities, buildings inhabited by horses, odalisques and other stage props of surrealism and de Chirico. Lüpertz's influence is also obvious.

Cologne has a painting community with a very different complexion to that in Berlin. Painting there has centred on the now disbanded artist's group the *Mulheimer Freheit*. Founded in 1980, and named after the street in which they had a joint studio, the most significant members of this group were Peter

32. Salomé. *Wild Boys*. 1980. Various techniques on canvas, 240 × 400 cm. (95 × 157 in.) Private collection

33. Dieter Hacker. *Red Earth*. 1984. Oil on canvas, 192 × 286 cm. (76 × 113 in.) Private collection

34. Walter Dahn and Jiri Georg Dokoupil. *Untitled*. 1985. Acrylic on cotton, 150 × 200 cm. (59 × 79 in.) Private collection

Bömmels, Walter Dahn and Georg Jiri Dokoupil, born in 1951, 1954 and 1954 respectively. Whereas the Berlin painters relied on the artist's subjective vision, they take a jaundiced view of such a romantic procedure. Descendants of Dada rather than utopian expressionism, the wit of Polke strikes them as more honest to the world than Lüpertz's tragic vision. Another major influence on them was the stylistic variety of Italian artists such as Cucchi and Clemente, who first exhibited their work outside Italy, in Cologne. Conscious of being deluged with the images of the mass media, the *Mulheimer Freheit* responded with a counter-deluge of scabrous, quickly-produced pictures, which in their early exhibitions covered gallery walls with anarchic confusion. Their paintings were a kind of visual nonsense-rhyming in which Art, Freud and advertising were rifled for piquant images. Truth was not an absolute to them, neither was the artistic personality, with its style as consistent as a signature or fingerprint. Styles could be changed like suits of clothes. When Dokoupil had a retrospective in Essen in

35. Rainer Fetting. *Nude*. 1982.
Dispersion on canvas,
210 × 280 cm. (83 × 110 in.)
Private collection

1984, he organised it into sixteen separate sections, each with paintings of a different style.

Collaboration between artists is a signal feature of New Painting. Dahn and Dokoupil have worked together, Salomé and Fetting, and Penck and Immendorff. Sandro Chia and Enzo Cucchi have also collaborated, as well as the Americans David Salle and Julian Schnabel. Such works are normally a way of challenging notions of personal style and habit. They are also indicative of the social nature of this type of painting.

Each year Dahn and Dokoupil join forces for an assault on the restrictions of good taste in collaborative paintings. In their most recent set, a naked woman rides on a horse across what could be a boxing ring or a painter's canvas (Plate 34). Before her lies a grimacing man with all his limbs cut off, presumably by her. Holding an enormous brush like a spear, she begins to paint with his dripping blood. The unpleasantness of this image is increased by the deliberately tacky manner of painting, its stuffed-toy horse and banal shining sun. The image is intensified by all the possible readings – an exorcism of castration fears; a parable on painting as a result of pain; an illustration of the female principle creating a living art from the dead. The meaning is open-ended. What is most important is that it excites our subconscious and breaks down our sense of decorum through an appeal to fantasy, desire and fear.

If Dahn is the more natural painter, Dokoupil compensates by his adroit use of format, design and style. It is such self-consciousness of style and striking design sense, together with an underlying emphasis on sexuality that unites his paintings: from his ectoplasmic abstractions and graffiti paintings of 1981, to his baroque series of the following year and African art pastiches of 1983. He is very much the necessary corrective to Dahn, whose work leans toward destructive expressionism.

The mixture of gentle lyricism on the border of the *Amsterdam Picture* (Plate 36) of 1982 and the brutality with which Dokoupil treats the figure – apparently composed of butcher's left-overs – is typical of the dichotomy between love and sexuality that is constant in his work. Like Polke, he is always asking us to make connections between dissimilar things. Maintaining the original intentions of the *Mulheimer Freheit*, his art is a form of guerilla warfare, deflating clichés with wit and energy, as in his untitled painting of September 1981 (Plate 38), a ruthless parody of the portentous myth paintings of A.R. Penck.

One constant theme in New Painting is the loss of personality and a corresponding fragmentation of the body. This is especially typical of Dahn, as previously noted of his headless painter searching for the icon of the twentieth century. In *Double Self* (Plate 37), one of the painter's two heads (both are blocks of wood) has an axe buried in it. It is an image at once horrific and richly comic. At his most extreme, as opposed to his most funky with *Baselitz – Pop*, he can produce images of straightforward shock. *Asthma I* is truly ghoulish with its death's head crawling out of the sufferer's throat. But, however many jokes he uses as camouflage, his essential vision is one of horror.

36. Jiri Georg Dokoupil. *Amsterdam Picture: from the Baroque Order series*; no. 6 – 'all coffins of this world hate the heart, I lie dead in them.' 1982. Dispersion on canvas and newspaper, 230 × 230 cm. (91 × 91 in.) Private collection

37. Walter Dahn. *Double Self*. 1982. Dispersion on cotton, 200 × 250 cm. (79 × 98 in.) Private collection

Peter Bömmels applies his paint wilfully, giving the illusion that his pictorial myths emerge naturally from it. The imagery of his paintings is often reminiscent of children's book illustrations with their rivers, woods and figures merging into one another. But a painting like *Finis* (Plate 39) is not an innocent idyll. There is a sense of being caught in these fantasies, where it seems that the artist himself, with the straw stuck up his nose, is unable to differentiate his own body anymore from the sliminess of primal matter. His more recent paintings, with their encrustations of human hair, may be seen as a comment on Kiefer, placing his fetishism for materials firmly back in the nursery.

A countermovement in Cologne is a *rapprochement* with romantic landscape imagery, an issue that has also been adapted by Berlin artists Bernd Koberling and Bernd Zimmer. Christa Naher looks at animals and the romantic imagery of the sublime from the viewpoint of both Freudianism and feminism. In her dark muted paintings, horses emerge from the darkness while naked women wait in the foreground. These women, however, are not presented as passive sex objects but as assertive archetypes contesting this world of dreams and primal desires. Volkar Tannert in paintings like his *In Praise of Work* (Plate 40), creates a romantic atmosphere which is subverted by the presence of factories and other buildings. He tries to examine that perennial notion of the landscape as home for the soul, hence his reliance on archetypes rather than observation.

Next to Kiefer the most important figure working with landscape imagery is the Dane Per Kirkeby, who spends half the year in Germany – which he has long regarded as the centre of art today – and the other half in his native

38. Jiri Georg Dokoupil. *Untitled*. 1981. Dispersion and collage on cotton, 153 × 268 cm. (60 × 105 in.) Private collection

Copenhagen or on an island in the Baltic. Born in 1938, he studied geology at Copenhagen and between 1958 and 1964 went on expeditions to Greenland, Iceland and Pearyland. These landscapes and those of the Baltic are constant themes in his paintings, poems and films. And they constantly recur in his essays, as he writes: 'The geologist turns back home to the camp. Now he is walking over the large terraces, the surface of large blocks of the melt water plains. They go into the landscape. Figures in the landscape are always swallowed by Nature. They wander into it – dots, stones, patches of snow – all is without size, crystal-clearly divided up, the terror cannot be located.' But all these emotional experiences of landscape, sometimes lyrical, sometimes horrific, are offset by a geological and scientific sense of the forces behind the forms of Nature. The geologist responds warmly, but records cooly.

So it is with Kirkeby's art. The paintings he has been making since the sixties are each a sequence of layers recording atmosphere, emotions, ideas and light. Images of horses, trees and people appear in them like flies caught in amber, or memories in the mind. In an untitled painting from 1981 (Plate 42) the tilted torso of a white horse is jammed into a compressed volume of scumbled and scratched greys, greens and blacks. It is like a compilation of memories and feelings. As landscape paintings, they are about landscape experienced through time; the sensation of a walk through the country rather than a single view of it.

In Kirkeby's painting *Vibeke in the late Summer IV* (Plate 41) (named after his wife), these sensations may appear almost totally abstract. But the play of light and material is that of the natural world and it is often evident, as here, that as a young artist Kirkeby looked to Turner and Constable for inspiration. At times elegiac, at times meditative, his paintings are about structure and a sense of

39. Peter Bömmels. *Finis.* 1981. Dispersion on cotton, 138 × 215 cm. (54 × 85 in.) Private collection

40. Volkar Tannert. *In Praise of Work*. 1985. Oil on canvas, 180 × 130 cm. (71 × 51 in.) Private collection

41. Per Kirkeby. *Vibeke in the late Summer IV*. 1983–4. Oil on canvas, 200 × 130 cm. (79 × 51 in.)
Private collection

presence in the world. They give us the taste and palpability of living in this world.

 It is a far cry from his work to the productions of *Gruppe Normal*. These three painters, Peter Angermann, Jan Knap and Milan Kunc produce small, jolly and colourful canvases of bourgeois Germans in unusual situations – a miniature *hausfrau* vacuuming the drawer of the desk in which she lives – or cartoon-like fantasies. Kunc's *Crocodile Village* (Plate 43) is typical of their transformations: a crocodile becomes an island covered with huts, an Arab boat nearby has the crescent moon for a sail. They are obviously heirs to the middle-European tradition of graphic fantasy. (Kunc and Knap are both, like Dokoupil, from Czechoslovakia). For all their popularity, these artists normally lack the pungency of the Surrealism they claim to have revived. Whereas most German artists are in opposition to their society or its ideology, *Gruppe Normal* is content to nudge it good-humouredly.

 The Hamburg artists are the most consciously political of all in Germany. But their political position is very much an oedipal and anarchic revolt against establishment paternalism. There has never been so much humour in German painting as now: from the wit of Polke and the gallows humour of Dahn,

42. Per Kirkeby. *Untitled*. 1981. Oil on canvas, 200 × 240 cm. (79 × 94 in.) Private collection

to the salacious fusillades of Werner Büttner and Albert Oehlen, the leading Hamburg painters.

Büttner denies that painting can be implicitly truthful and spiritual, and asserts that it is only one medium with which to communicate amongst others. Given this, it is curious that he should paint so fluently, but he does bend this ability against itself. *Brothers with Music (New York)* (Plate 44) does not just revamp the story of Cain and Abel in terms of a street mugging, but piles on irrelevant details – the musical notation, the ugly smear of white paint over the victim's body – so as to disrupt our pleasure in the picture.

Oehlen, too, plays games with the medium that he does not respect, yet seems to be obsessed with it. In his *Self-portrait with Palette* (Plate 45) of 1984, he stares back at us lugubriously. The conflation of the geometric figure he is drawing and the skull in the crook of his arm is both absurd and serious. As with Büttner, there is the paradox that his paintings are often strangely beautiful; even when he mixed Quaker Oats with his paint in his colour theory paintings of

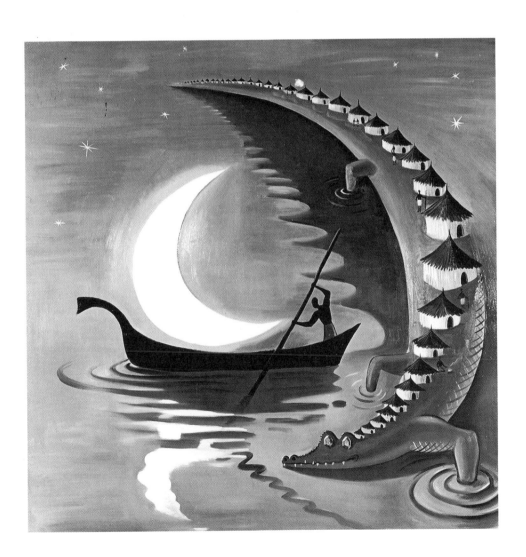

43. Milan Kunc. *Crocodile Village*. 1985. Oil on canvas, 120 × 120 cm. (47 × 47 in.) Private collection

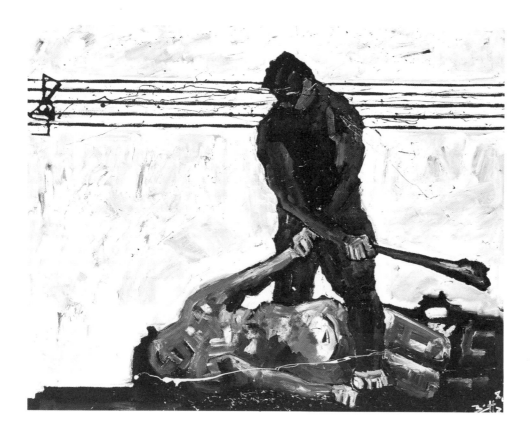

44. Werner Büttner. *Brothers with Music (New York)*. 1984. Oil on canvas, 150 × 190 cm. (59 × 75 in.) Private collection

1981 (ostensibly to discredit the medium), it resulted in a beautiful surface, for all the porridge-like consistency.

In their desire to find a reason for painting's appeal as an activity other than dubious explanations in terms of spirit, many artists and commentators look to Freudian notions of the anal drive. The first thing we make, the first present we have to give as children is our own excrement. This desire to give form to the expression of our body remains constant, albeit repressed, throughout life and can most naturally and healthily be sublimated through painting. At its most extreme, painting is seen as golden faeces. No doubt Oehlen's *Self-portrait with be-smirched underwear and a Blue Mauritius* (Plate 46) expresses this. The Blue Mauritius, the most valuable of stamps, is a brilliant blue against the browns and greys to which Oehlen (and Büttner) normally confine their palettes. Its juxtaposition with his excrement points out that painting is at once of unwholesome origin and of great value. This view of the artist is in direct opposition to Beuy's notion of the artist as shaman and redeemer.

Across the southern border, one finds the related but separate painting tradition of Austria, a country that gave up imperial pretensions to glory long before Germany. Emptiness, spiritual malaise and trauma have been the central experience of its artists throughout this century. The tendencies toward pessimistic expressionism and even exhibitionism, traceable as far back as the work of

Egon Schiele and Oskar Kokoschka, reappeared in the fifties and sixties with the performance work of artists such as Gunter Brus and Hermann Nitsch. Their work was famous, or notorious, for its blasphemy and extremity. Nitsch's performances sometimes involved the disembowelling of an animal carcass, with the entrails then spread over his collaborators. One of the most bizarre spin-offs of New Painting has been the marketing, as paintings, of blood-stained ecclesiastical vestments from Nitsch's 'actions'.

Of this generation, Arnulf Rainer, born in 1929, has demonstrated a total commitment to picture-making. At their most extreme, his paintings are comparable to Nitsch's performances. His work of the fifties depicts either a cross shape or a surface entirely covered with black or red thickly matted paint; paint concealed or destroyed as much as defined. This principle was extended to a long series of overworked photographs of his own grimacing and contorted face: tangles and swathes of aggressive black lines across his features, at once

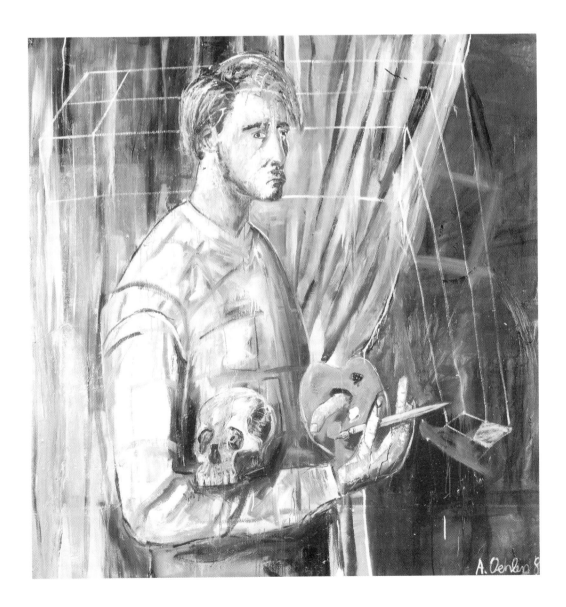

45. Albert Oehlen. *Self-portrait with Palette*. 1984. Oil on canvas, 180 × 180 cm. (71 × 71 in.) Private collection

46. Albert Oehlen. *Self-portrait with be-smirched Underwear and a Blue Mauritius.* 1984. Oil on canvas, 240 × 260 cm. (94 × 102 in.) Private collection

destroying them and emphasizing their emotions. Likewise, in his recent crucifix paintings, thick, tarry, black oil paint has not only been tugged across Christ on his battered cross, but over an underpainting of brighter colours as well (Plate 47). For all its apparent violence, its real effect is again to enthrone Christ as victim.

Rainer's crosses are painted primarily with his hands, and it is easy to see his painting methods as a form of performance in which the whole body expresses itself. This is especially true of the 'chaotic' paintings of 1982 where he worked on sheets of card upon the floor, using his hands, knees and feet to spread the paint, crawling and falling in last, desperate, painterly gestures. Some of his best recent works have been made in collaboration with Günter Brüs, where Rainer's finger marks and smears of paint cross Brüs's wraith-like figures (Plate 48). They are works that are both full of aggression and pathos; just as Brüs's skull weeps, so does Rainer's body.

Just as in Germany, so in Austria is there a whole clutch of younger painters impatiently following on the older: Siegfried Anzinger, Erwin Bohatsch, Hubert Schmalix and others. Despite the parallel they seem to make

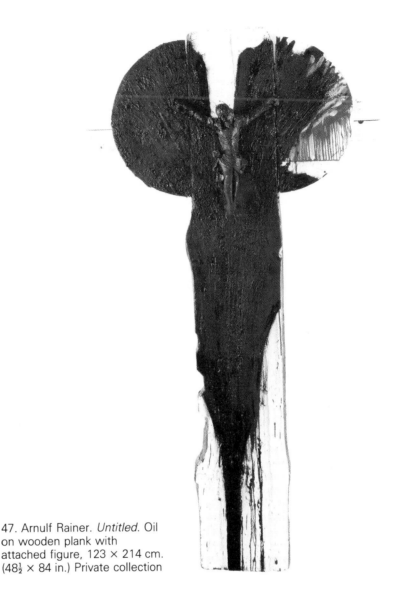

47. Arnulf Rainer. *Untitled.* Oil
on wooden plank with
attached figure, 123 × 214 cm.
(48½ × 84 in.) Private collection

with *Heftige Malerei*, they are more inward-looking, dreaming rather than
frenetic. They have a much stronger sense of paint as a substance than the
Berliners and a far less strident imagery.

Whereas German artists, following Baselitz, tend to contrast figure and
ground, the Austrians tend to merge them, as though the paint surface is one
uniform, albeit troubled, skin. This was so even in Anzinger's early work in
which figures – for example, a man carrying a skull, or an angel – merge with
splashes and strands of bright paint. Improvisation and disruption was constant
across the canvas. Recent paintings have more unified colouring, normally grey-
blue. The figures are very much part of the paint surface, as though they were
evidence of a heart beating under its skin. They are also more modelled and
always suggesting trauma: a figure of Oedipus with hands over head, monstrous
in isolation (Plate 50); Icarus, emaciated and covered with ashes, walking away,
head bowed.

Even in that most placid of countries, Switzerland, we find an artist
whose work is based on subjectivity and ecstasy. Martin Disler, born in 1949,

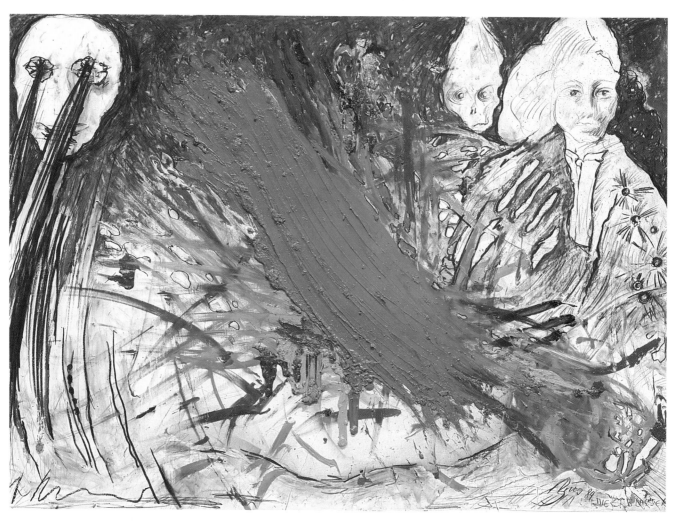

48. Günter Brüs and Arnulf Rainer. *The Pale Ones.* 1984. Mixed media and oil paint on photograph, 121 × 80 cm. (48 × 31½ in.) Private collection

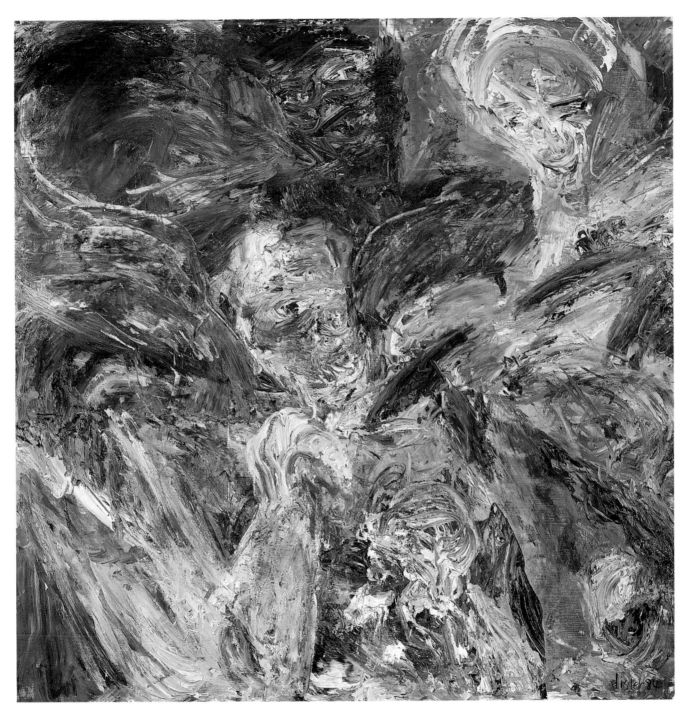

49. Martin Disler. *When the Wolf cries*. 1984. Oil on canvas, 150 × 150 cm. (59 × 59 in.) Private collection

50. Siegfried Anzinger. *Sugar Penis*. Oil on cotton, 69 × 59 cm. (27 × 23 in.) Private collection

was initially more a poet than a painter and he still publishes poetry, notably in books like the *Black-White Novella* where his short, free-form poems are combined with his abrasive, even fetishistic drawings. The book tells of the hallucinations of two lovers trapped in a bureaucratic camp of horror; they eventually escape through the power of love and art. It is a theme frequent in his work, which is often a celebration of physical love and desire. The notion of his body intermingling with his surrounding and with others is constant. Such a cathartic loss of personality, which we see in other artists of his generation, probably has its historical roots with the hippies and their drug-induced states of ecstasy.

Like the Austrian artists, Disler has worked in performance, and the physicality of such work is present in his works, particularly in his enormous, specially-installed paintings. One recently painted in the Serpentine Gallery in London, *Streams of Eros*, was a 10 × 10 m. room covered in cartwheeling red figures weaving in and out of each other; in effect as though a fountain was spewing forth blood and naked bodies in a violent and sexual dance.

In his smaller paintings, this frenzy is compressed. The bodies in *When the Wolf cries* (Plate 49) tangle and knot more tightly into what is at once a vibrant, energetic surface and an image of flesh made alive. In another easel-size painting, *Diving for Treasure*, he is again facing the mirror of the canvas, directing that frenzy and ecstasy inwards to the imaginative riches present in our own minds.

3 ━━━━━━ ITALIAN COLOUR, POETRY AND SKULLS

You ask me to explain my statement that 'art is like wind which makes waves'. But this is art: the millenial wind which brings with it the wonder of things, feeling, light.

Enzo Cucchi

For Italian artists the past is always present. There is scarcely a town in Italy that does not have an important altarpiece, or an interesting *quattrocento* fresco. When artists and their public began to weary of the performance and Conceptual art that was the radical chic of their day, it was perhaps inevitable that they should turn to that painting tradition whose evidence was all around them.

Salvo, who had made his reputation as a Conceptual artist, was the first 'to return' to painting, starting in 1973, with large coloured drawings based on the masterpieces of the Renaissance. Reproduced here is one adapted from Carpaccio's *The Triumph of St. George* (Plate 53). The changes that he has made to the original are important: the size has been increased, the colours are less natural and, most crucially, the background has been omitted so as to concentrate on the motif of the saint decapitating the dragon. When Salvo began to paint in earnest, rather than using it solely as a strategy with which to talk about art, he kept these pale but luminous colours and this lack of background detailing to emphasize the dream-like or archetypal quality of his images.

Salvo detested the realist painters as much as he did the conceptual artists whose company he had left (and all of whom still do not speak to him). His concern was with a personal vision: his painting *Factory* (Plate 51) of 1981, with its buildings reduced to brightly-coloured cubes and its cotton-wool plumes of smoke unbraiding against an orange sky is utterly beautiful and utterly unrealistic. Like any strongly-felt personal vision, it often jars our ordinary perceptions; factories and their chemical polution are not normally seen as beautiful. Salvo is at once asking us to regard the beauty that can be abstracted from this world, and at the same time recognizing the difference between the poetic vision and what he sees as the degraded vision of the realist. With all their simplifications and child-like qualities they are, like Turner's paintings of which he is so fond, paeons to light and the light-drenched landscape.

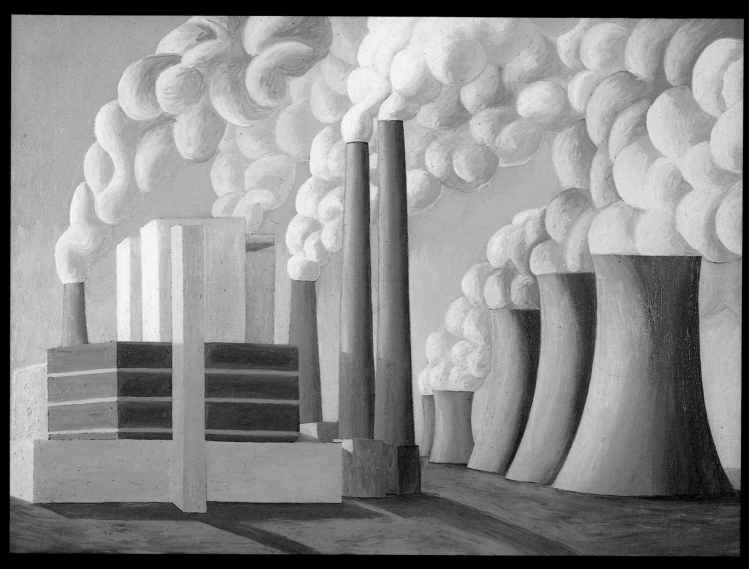

51. Salvo. *Factory*. 1981. Oil on canvas, 91 × 128 cm. (36 × 50½ in.) Private collection

52. Sandro Chia. *Under the Tree*. Oil on canvas, 244 × 197 cm. (96 × 77 in.) Private collection

For those Italian artists who, like Salvo, returned to painting, there were two tendencies to follow. Firstly, there was the persistent wit, elegance and poetic quality of Italian art and design. Even most Italian conceptual or installation art had been highly poetic or allusive, for instance, Jannis Kounellis with his plaster casts of classical sculptures and smoke stains on the wall, or Mario Merz with his bundles of twigs and igloos of broken glass. Secondly, there was the rediscovery of the artists from between the wars, not only de Chirico, but his brother Savinio as well, and Carrà, de Pisis, Sironi and others. All of them had been decisively influenced by metaphysical painting, that precursor of Surrealism where imagery drawn from the irrational and subconscious is projected in terms of Renaissance illusionism. Although most of these artists carried on to develop individual, eclectic styles, they had in common a belief in the potency of myth and a notion of style as an artistic freedom rather than a restriction – a suit of clothes, not a straitjacket. For today's artists, they showed a way in which to deal with a painting tradition, which, however grand, had been broken and decayed since the eighteenth century. As Salvo remarked:

> This end of the century? It is, I would say, a time of stagnation . . . Certain things have happened – it's clear to everybody that this so-called *avant-garde* has got to finish. It had worked itself into a cul-de-sac, it had degenerated into mannerism. You had only to do the most minimal thing for it to 'work', to use nothing but black and white. So at a certain moment I broke the rules; I said let's do something green, red, yellow and blue.

It is a curious fact that Sandro Chia, born in 1946, is probably the most important painter to come from Florence, that most artistic of towns, since Bronzino in the early sixteenth century. Reportedly, thirteen-year-old Chia slipped on a slimy river bed and knocked himself out on a rock when trying to fish with his hands. A week later he awoke to find out that not only had he reached puberty but that he had suddenly developed a fascination with art. Whether or not this anecdote is strictly true, it *is* typical of the way in which Chia has sought to remythologize both life and art. When he began to exhibit, the subject-matter of his paintings

53. Salvo. *The Triumph of St. George (after Carpaccio).* 1974. Coloured pencil on card, 270 × 760 cm. (106 × 299 in.) Private collection

54. Sandro Chia. *Frontier Soldier*. 1979. Oil on canvas with two plastic bowls, 80 × 60 × 28 cm. (31½ × 23 × 11 in.) Private collection

was often concerned with such 'miraculous transformations' as his own puberty. In these early paintings, there is an enormous sense of release, as though all the images had been accumulating and then, when the dam burst, had come flooding out. Figures that are larger than life bound across a landscape that is in a state of multi-coloured flux. There is, in his return to painting (and this is true of others), something of the fervour of the religious convert who has gone through the tribulations of sin in order to discover God and grace:

I've been through conceptualism, minimalism, everything. There is a new richness to our perception because we went through all that. Now that it's possible to look at paintings again, we see it not only as paint on canvas, but as something else . . . A painting is not just an object: it has an aura again. There is a light around the work. It is a miracle, in a way. A total concrete, physical miracle. Painting is made with heavy things – stretchers, canvas, paint. Heavy, dirty things. But they become Light.

This transformation of material, this poetry of objects was also part of the work done by Kounellis and Merz and we see Chia's kinship with them in *Frontier Soldier* (Plate 54), 1979. In it, two plastic bowls are placed on a ledge

before the canvas; the image is one of enlightenment and within that context they become sacramental objects echoing the shapes made by the light. The soldier's mouth hangs open, his chair falls over as he rises from it. He has been struck to the quick by something he has read. And just as in Chia's painting *Genoa*, in which figures float into the sky, things have become unreal and elated.

A similar moment of enlightenment is recorded in his painting, *Under the Tree* (Plate 52), in which a male figure stares at what is apparently a diamond exploding in his hand; all around the landscape dissolves in glorious pyrotechnics. Chia's landscape backgrounds often have these glowing patterns, palpitating with possibility. It is a child-like perception, as though the world has only just been discovered. For all his knowledge of art history, he uses devices from the past with surprising innocence, notably Futurist techniques to express movement.

Sadly, Chia has not maintained this exhilaration in his work. Whether it is because he has temporarily exhausted his stock of images, or whether he has been adversely affected by his success and move to New York, his recent paintings have lacked the same clarity of vision. The patterning that once was vibrant has become clogged with awkwardly-handled paint. Perhaps, as with an artist like Salomé, the initial excitement of expressing oneself in paint could, for a short time only, conceal deficiencies in technique. One suspects, however, that an artist of Chia's ability and originality will regain his 'form', having welded a more complete technique to his poetic vision.

It is on Chia, Francesco Clemente, Enzo Cucchi, Nicola de Maria and Mimmo Paladino, known collectively as the *trans-avantgarde*, that the high reputation of contemporary Italian painting largely rests. Although they now rarely work together, they were shown collectively at the end of the seventies, notably in Cologne, where they have had a great influence. Above all else, they were promoted by the verbose and rhetorical but influential book *The Italian Trans-Avantgarde*, written in 1979 by the Rome art critic Achille Bonito Oliva. For Oliva, these five artists had gone beyond the *avant-garde* and its pre-established revolutions to claim a nomadic and eclectic attitude to culture. Or, as he put it with typical orotundity, 'the *trans-avantgarde* spins like a fan with a torsion of a sensitivity that allows art to move in all directions, including the past'.

Certainly, they have re-established contemporary painting within a larger tradition than just that of Modernism. Of the five, Chia alone comes from Florence; Cucchi is from Ancona and the other three are from Naples, as are many other young artists. Although it may be an economic backwater, it is a place imbued with history, a meeting place of different cultures. It is also a city in which the realities of life, pain and beauty, are unusually exposed. In no other place are Life and Death so close as in Naples, with its teeming crowds, its ornate funerals and its repellent slums; and above, it is over-looked by Vesuvius, which in antiquity destroyed the cities of Pompei and Herculaneum almost instantly with fire and ash.

55. Mimmo Paladino. *Noa Noa*. 1983. Oil on panel, 53 × 40 cm. (21 × 15¾ in.) Private collection

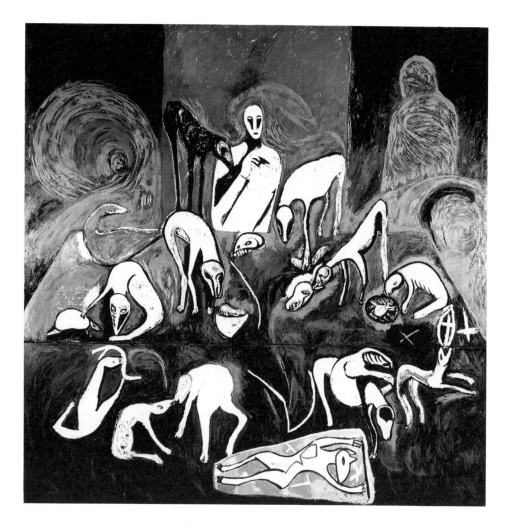

56. Mimmo Paladino. *Crib.*
1982. Oil on canvas,
300 × 300 cm. (118 × 118 in.)
Private collection

Death is omnipresent in the paintings of Paladino, an artist born in the countryside near Naples in 1948. Skeletons and wraiths haunt his large pictures. Against Death, he places the subjectivity of painting and the instinctual life of animals. His total belief in the former is illustrated by a painting made in 1978 in which a tongue emerges from a terracotta head of himself, stretching across the entire canvas to touch the other, distant corner. It is his belief that the physical act of painting allows images to emerge from the depths of his soul and go straight, unchanged, onto the canvas. Regarding his instinctual work, Paladino has said,

I paint, draw animals spontaneously, because they please me and because I am interested in nature. Nature possesses something mysterious: its impossibility of communication with people. Nature is original, wild, always fascinating, always new to discover. I am interested not only in the context of art, but in the mysterious, the inexplicable, the forgotten. When I create a work I want to penetrate to exactly these areas.

57. Nino Longobardi. *Untitled.*
1984. Ink on paper,
40 × 30 cm. (15¾ × 11¾ in.)
Private collection

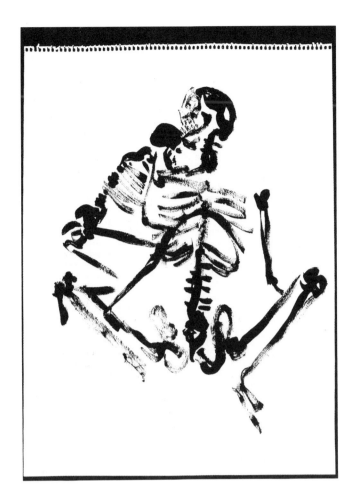

58. Arcangelo. *In my Spirit.*
1983. Charcoal, enamel and
tempera on canvas,
240 × 330 cm. (94 × 130 in.)
Museum of Toulouse

Like many contemporary artists, Paladino is fascinated by myths – Roman, Mithraic or others – and by late nineteenth-century Symbolist poets such as Rilke and Yeats. Indeed, although he is reluctant, like other artists, to explain his work, his larger paintings often seem to express complex allegories. In *Crib* (Plate 56), a large, mainly red painting from 1982, a dozen dogs are shown eating or playing with one another, while a man holding a mask looks on. Although the picture is about animals, it is also a parody of the Last Supper with dogs playing the part of the disciples – the black dog is no doubt Judas – while in the foreground the thirteenth dog portrays Christ, either asleep in his crib or dead in his coffin. And behind the watching man, who is perhaps a projection of the artist himself, loom three threatening figures.

It must be admitted that Paladino's large pictures have sometimes become too generalized and mannered to be effective, their portentous messages at odds with their decorative figures and empty spaces. (Recourse to the subconscious and the intuitive can turn up clichés as well as truths.) Often, his smaller pictures have a more poignant juxtaposition of images and a more concentrated colour effect. In *Noa Noa* (Plate 55) (a title that refers to Gauguin's book written in Tahiti), a shape that is at once a face, a foot or the prow of a boat butts against a dreamer's head. Its frame of driftwood is covered by primitive-looking magical markings.

Whereas Paladino looks to animals, his ex-pupil Arcangelo concerns himself with the landscape, or as he, symptomatically, calls it, *Terra* (earth). His large drawings and paintings are often frottaged against the very earth itself (Plate 58). They are concerned with a total physical and instinctive communion with the world which we live in. Indistinct shapes and a sense of immanence slowly emerge from these meditative paintings.

In contrast, Nino Longobardi's shapes quickly resolve themselves as skulls and skeletons (Plate 57). His work, heavy with echoes of Goya, is a modern Dance of Death, where both living and dead figures are caught in an endless round of activity. Another young Neapolitan, Silvio Merlino, fills his paintings with all the life of the bay of Naples: a multitude of creatures teem in a swirl of sea, light and material. There is a sort of natural magic in his painting. When he wishes to picture a deer, he fits some deer skin and a glass eye into his paintings (Plate 59). This is the world portrayed with the excitement of the child, or by someone who has just regained their sight; it is about recreating the world in terms of myth, magic and material.

Francesco Clemente has the widest range of the Italian artists. Painting in fresco, water-colour, oil or pastel as well as producing miniatures and sculptures, his style varies from thick expressionist painting, through the calmness of frescoes (Plate 60), to the often mordant wit of his many drawings. His life has been as nomadic as his attitude towards style. Born in 1952 to wealthy and artistic parents, he divides his year between New York, Rome and Madras. Like all the best travellers, he is open to all experiences, ideas and beliefs: 'I am absolutely religious. Any religion finds me consenting to it. I believe in what is told me about religion each time it is proposed to me.' His

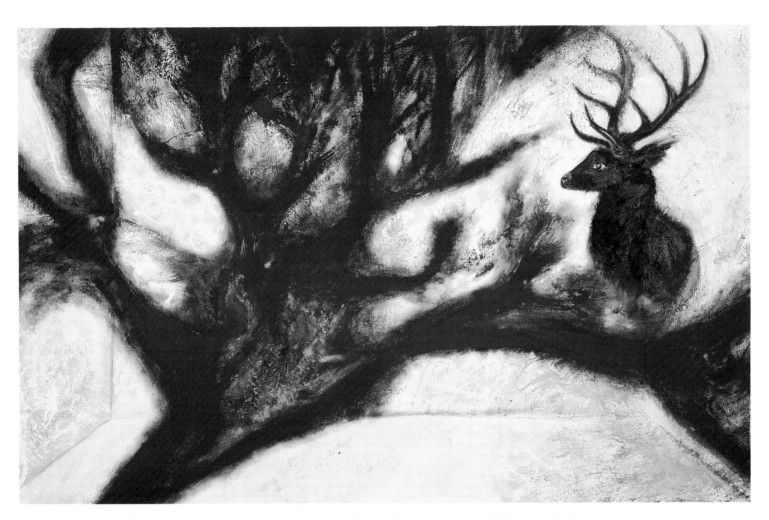

59. Silvio Merlino. *The Deer*. 1984. Mixed techniques on card, 180 × 280 cm. (71 × 110 in.) Private collection

61. Francesco Clemente. *The Midnight Sun No. VI.* 1982. Oil on canvas, 198 × 237 cm. (78 × 93 in.) Private collection

60. Francesco Clemente. *Julian Schnabel.* 1981. Fresco, 210 × 145 cm. (83 × 57 in.) Private collection

voracious appetite for experience and imagery is necessarily transformed by his aristocratic wit and irony. He finds inspiration in everything: Indian film posters, baroque art, Cy Twombly (from whom he first got an enthusiasm for modern art) or the work of his friends Julian Schnabel and Brice Marden. He believes in the artist as a seer, but one appropriate to this age; hence, William Blake and Fuseli are important to him because they 'might be considered the first Western painters to take a close look at bad taste, to see truth as bad taste'. Like many of his generation, he is fascinated by de Chirico and Picabia because 'they're the two painters that have claimed to be dilletantes in order to maintain the integrity of their inquiry, and they have shown that eroticism and humour aren't held hostage by an age, whereas ideas are'.

Certainly, a painting like the sixth of the cycle *The Midnight Sun* (Plate 61), made in 1982, is full of humour and eroticism. In it, a naked man holds up a naked woman, who herself holds a diminutive man. After awhile, we realize that the man is making love to the woman and that the manchild she is holding is the offspring. But why is the man, who has Clemente's own features, wearing three coats, coloured red, yellow and blue? Do the stage lights to either side indicate that this is some sort of performance, a conjuring trick perhaps? At times, Clemente does seem like a travelling showman, endlessly wandering, observing

62. Francesco Clemente.
Ortus Conclusus
(Enclosed garden). 1983.
Gouache on linen,
198 × 472 cm.
(78 × 186 in.) Private
collection

63. Francesco Clemente.
Weight. 1980. Pastel on
paper, 61 × 46 cm.
(24 × 18 in.) London,
Saatchi Collection

64. Nicola de Maria. *Reign of Flowers*. 1983–4. Mixed media on canvas, 84 × 65 cm. (33 × 25 in.) Private collection

and absorbing strange knowledge; occasionally stopping to perform, demonstrating these mysteries, but never explaining.

Inevitably, with an output as prolific as Clemente's, (for his 1985 show in New York he filled three large commercial galleries) the quality of his work is variable; but at his frequent best it is so poetic, so beautiful and so sharp that he appears as much a modern master as Kiefer or Baselitz. Apart from his inexhaustible imagination and fluent draughtsmanship, he has an acute sense of colour, apparent in the large painting *Ortus Conclusus* (Plate 62) (enclosed garden). Apart from the skull and woman (echoing *Et in Arcadia Ego*), it is almost entirely abstract: mottlings of red on pinks and brown, marblings of green and blue, all in the unusual medium of gouache on linen. It is as lyrical as any colour field painting by Morris Louis; the presence of Death and the Maiden only giving it another layer of meaning and heightening its poignancy. Again, the curious image in the pastel *Weight* (Plate 63) may make us miss the elegant and melancholic colouring. Against a pale lime background a naked woman, her hair braided into a weight, holds Clemente's head, while all around flowers bloom and turn to smoke. The mood, like the imagery, is bitter-sweet. Life in his paintings is transient but beautiful.

65. Alberto Abate. *The Generation of Pasiphäe.* 1984. Oil on canvas, 220 × 180 cm. (86 × 71 in.) Private collection

66. Ubaldo Bartolini.
Landscape. 1984. Oil on
canvas, 50 × 70 cm.
(19½ × 27½ in.) Private
collection

It is, above all else, a joy in colour and light that distinguishes the Italian painters from the Germans. Their works evoke the clear light and bright colours of the Mediterranean. Of no one is this more true than Nicola de Maria. In the late nineteenth century, several poets saw colours as being equivalent to musical notes or specific images; de Maria develops this, but in terms influenced by American colour painting. His most famous works have been completely coloured rooms, like the one in the Villa Celle which he painted between 1975 and 1982 – orange crescents and a floating green panel appear against a luminous blue; a suitcase lies on the floor, painted with areas of green and red. It is like being in a garden of richly-scented flowers and sharply-singing birds. Here, painting aspires to the condition of music. In recent years, he has turned to the production of more conventionally-sized paintings. The *Reign of Flowers* also expresses a delight in brilliant colours coupled with images of germination and fertility (Plate 64).

All these artists are eclectic in the way they pilfer the images and styles of past art, but some Italians have gone even so far as to blatantly copy or pastiche them. These artists, who are known as the *Anachronistici*, are remarkably popular in Italy. In their emphasis on correct academic techniques and a

67. Carlo Maria Mariani. *To See Oneself in a Celestial Mirror.* 1984. Oil on canvas, 250 × 200 cm. (98 × 79 in.) Private collection

68. Carlo Maria Mariani. *Study for 'The Hand obeys the Intellect'*. 1983. Pencil, pastel, water-colour, gouache and crayon on paper, 217 × 179 cm. (85 × 70 in.) Private collection

mythology in which no one has actually believed for centuries they are, according to some fashionable critics, deliberately demonstrating the emptiness of art and life today. The more cynical see them as producing scarcely-competent academic art spiced up with a rumour of Post-modernism. Certainly, there is little feeling in a painting like Alberto Abate's *Generation of Pasiphäe* (Plate 65) with its stiff poses, dead colours and hopelessly confused mythology. The landscapes of Ubaldo Bartolini which pastiche Claude Lorrain in oily and lugubrious paint, are equally sterile, though not without a quaint charm (Plate 66).

The most important painter of this genre is Carlo Maria Mariani. His desire to create masterpieces like those he has seen in museums (a desire shared by the Englishman Stephen McKenna and the Frenchman Gérard Garouste), has led him to become a sort of latter-day Ingres. Heroic male nudes wade through the surf bearing classical sculptures on their backs; an effeminate Ganymede is once again borne off unresisting to the Heavens, and once again Orpheus poses as a type of nude Melancholy. In *To See Oneself in a Celestial Mirror* (Plate 67), two nude poets hover in a decorative limbo like Dante's Paolo and Francesca. But though one enjoys the arabesques of the drapery and the delicately-tinted colours, the image is too sweet and too reminiscent in its postures of formation swimming to be taken seriously. As his drawing *The Hand obeys the Intellect* (Plate 68) indicates, in which two figures admiringly draw each other, this is essentially a narcissistic and hermetic form of art.

In contrast to such undigested regurgitations of the past, Omar Galliani and Robert Barni use such imagery with humour and poetry. What could be more comic or more horrifying, than Barni's large drawing *Pistoia* (Plate 69), in which the Renaissance town is reduced to children's building blocks and carted off by two leaping horses? A baggy-trousered man covers his face with his hand at the shock of seeing history collapse at the artist's fancy. The humourlessness of the *Anachronistici*, together with their dreary, dead paint surfaces, is easily exposed.

The poetry of Galliani is less robust, more evocative than Barni's. Once, his paintings were programmatic destructions of old masters: an image, for example, of the sphinx dissolving into a great swirl of paint. Although, like the *Anachronistici*, he may once have used an epidiascope to get an image placed on the canvas, the means by which he now creates a painting is much the same as those employed by Correggio and Parmigianino, his predecessors in his home town of Parma where he still lives. Just as in Correggio's frescoes saints dissolve into light, so in Galliani's paintings figures dissolve into the haze of a vision of the Mediterranean. Sensuous figures become clouds or waves (Plate 70). Unlike Mariani's, this is a world as much of textures as of images, a world in which the sexuality of the figures is not merely a museum memory.

Enzo Cucchi also remained in his birthplace, Ancona, a small port on the Adriatic, finding no reason to go anywhere else. He was brought up on a farm and his art is based on a peasant's intimacy with the earth and sea. His art is not about particular landscapes, but about feelings and atmospheres. As he said, 'I never look at what surrounds me. I'm interested in the places around me in terms of flavour and presence, but I'm not interested in looking at them . . . I don't represent the sea, I just feel the presence of the sea. To feel like the fisherman – who feels the sea and the danger.'

In order to convey these 'presences' Cucchi, like Kiefer, relies as much on a sense of touch as of sight. Pottery, rocks, hunks of wood, battered pieces of metal or piles of soil are sometimes attached to his paintings or placed in front of them. But above all else, he adds twigs or saplings such as a peasant would gather for kindling fires. In *A Painting that barely touches the Sea* (Plate 72), just such a bundle of sticks is tied to the deep, blue sea. The illusion of the sea and the shadowy ship behind is destroyed by that addition and we are forced to respond to the material values of the picture and the sensual experience of its colour, with paint piled so thickly that it forms ridges and lumps. Under his sticks float the ubiquitous skull of Italian art, watched by another on the shore. For Cucchi, the skulls are not merely macabre; painting can give life to that symbol of Death: 'it is not just a symbol, but a real thing. If you touch your head you feel the skull. In painting you can paint a skull and make something very lively'. In his series *Barbarian Landscapes*, cocks crow over whole fields of upturned skulls. This is reality.

Whereas Cucchi's recent work has been increasingly tactile and physical, his earlier work was notable for large drawings of enormous and simplified figures in a mythical landscape. Though he no longer produces these, which were

69. Roberto Barni. *Pistoia.* 1983. Charcoal and chalk on card, 320 × 270 cm. (126 × 106 in.) Private collection

70. Omar Galliani. *Untitled.* 1984. Oil on canvas, 173 × 182 cm. (68 × 71 in.) Private collection

71. Enzo Cucchi. *Untitled.*
1984. Black crayon,
40 × 18 cm. (15¾ × 7 in.)
Private collection

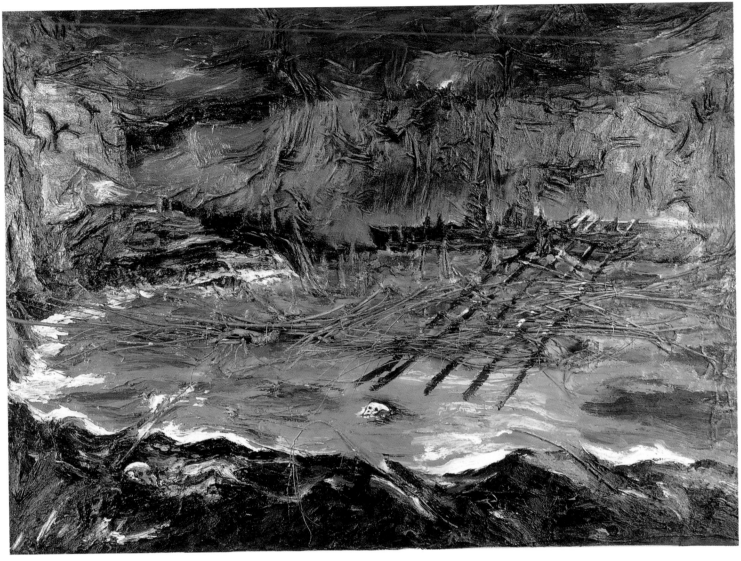

72. Enzo Cucchi. *A Painting that barely touches the Sea.* 1983. Oil and wood on canvas, 199 × 290 × 38 cm. (78 × 114 × 15 in.) Private collection

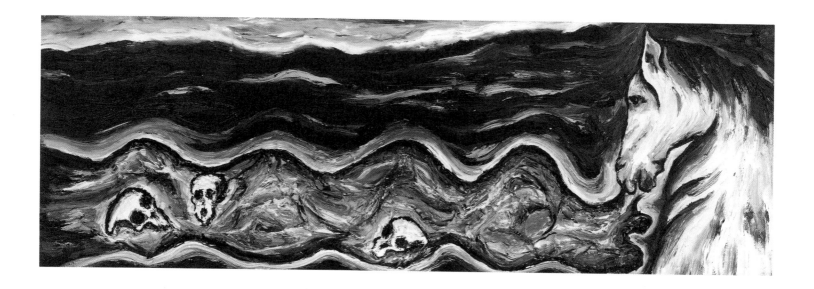

characterized by their mixture of dignity and humour, drawing remains essential to him. Like Clemente, he is a superb draughtsman. With sombre accumulations of black, his drawings have a visionary quality. Their scenes mix horror with comedy, simple objects with conundrums: two trees grow up through a beached boat, at the top their branches transfix two skulls; behind them looms a vast black cloud (Plate 71), which often in Cucchi's work seems substantial, more material than atmosphere. It is as if the sky were full of flying earth.

 Such conflations of the mythical or imaginary with the intensely physical are at the heart of Italian art. In Cucchi's *Mysterious Breath* (Plate 73) of 1983, a horse, a frequent symbol of the instinctive and the powerful, exhales breath. The breath spreads across the field dispelling darkness. What should it uncover but three skulls blossoming from the soil, emblems so typical of Italian painting – at once physical, comic, macabre and poetic.

73. Enzo Cucchi. *Mysterious Breath*. 1983. Oil on canvas, 100 × 300 cm. (39½ × 118 in.) Private collection

4 ━━━━━ BRITISH PAINTING AT THE CROSSROADS

One of the problems that you never hear talked about in Britain – nobody really talks about it anywhere – is the role of the unconscious in art and the discovery of the unconscious through the medium of art. I don't think I could have done anything if I'd stayed in England: I would have become a drunk!

Malcolm Morley

In most countries it has been relatively easy to point out the specific groups of artists who constitute the New Painting. It is not so in England. That it should prove difficult to identify was first evident in making the selection for *The New Spirit in Painting*. As this first gathering-together of New Painting was to be held in London's Royal Academy, it was obviously incumbent on the organizers to include a reasonable quota of British artists. This they did not by finding equivalent new British painters, but by turning to a whole group of established figurative painters, Frank Auerbach, R. B. Kitaj and Lucian Freud among them. For all their virtues, their work obviously belonged to a different ethos than the Italian and German contingent. A more satisfactory parallel to continental developments could have been found in the work of a group of young sculptors, Bill Woodrow, Tony Cragg and Anish Kapoor, who worked with transformed materials to produce images of great wit and imagination.

One British painter, however, was included in the exhibition who obviously did belong. Unlike the others, Bruce McLean, a Glaswegian born in 1944, had not committed his entire life to painting and drawing; he had trained as a sculptor and then worked as a performance artist. It was only in 1977 that the plans and sketches for these performances, which satirized fashionable or bureaucratic worlds, began to be exhibited in their own right as paintings. As full of wit as his performances, they revelled in their bright colours, exuberance and improvised execution.

Exit the Hat (Frontispiece), one of four paintings made in Berlin for *Zeitgeist*, is typical. It is, as McLean says, 'like a spectacle, a performance on canvas'. The response from German artists to him had been, according to McLean, 'Ah, hullo Bruce . . . the *werke* is OK, but has no *angst*, is too frivolous'. His characteristically contrary reaction was to accentuate the apparently frivolous and decorative aspect of his work. But as so often apparent in his work, his frivolity was deceptive: the images were necessary correctives to

the nightclubs of Salomé or Middendorf with their *angst* and indulgence. Here the inhabitants do not dance in solitary frenzy, but mutter inanities at one another. The world on which he comments is a social one.

Although McLean's recent paintings, which often feature socialites wearing socks, boots or handbags on their heads, continue to lampoon the fashionable, they use colour with increasing sophistication and freshness. Here, wit has more to do with poetic precision than with jokes. This is especially true of his paintings of the Oriental garden at Kyoto in which a few plants, a few fish and a vast splash of white paint on a black canvas are sufficient to evoke a timeless harmony.

It was not, however, from performance or Conceptual artists that the main thrust of New Painting in England developed, nor was it from the figurative painters but, perhaps surprisingly, from those very abstract painters whom New Painters normally oppose and reject with most zeal.

To a greater extent than other European artists, the English had been in thrall to New York painting. But such an art of surface phenomena was, unlike its American counterpart, often riddled with references to the landscape. Also, many of these abstract painters tended to seek kinship with late Impressionism and Venetian painting. In so doing, they inevitably imitated the way Titian and Tintoretto expressed or sublimated feelings in paint. These implications have been pushed to their logical conclusions by the painter Gillian Ayres, born in 1930, who symptomatically described Titian's paintings as, 'arrangements of limbs, hair, drapery, walls of human bodies . . . all used in overwhelming rhetorical grand movements of compositions, with the fullest use of light and shade. Glazes are used to create an iridescent lustre, to combine with the erotic sublime.'

Ayres moved from the use of acrylic to oil paint in the late seventies, and the resulting paintings were heavy with paint, modelled with her hands like sculptor's clay. Her vision of the 'erotic sublime' and 'walls of bodies' is a vision of the world-as-flesh-as-paint. Her painting invests materiality with meaning. Both the colour and the substance of the paint are emphasized and all the evidence of its physical transmutation is prominent: the smears and twists of arm and hand, the wrinklings and puckerings that thick paint makes when drying. Her painting *Venice and Neptune* (Plate 74), with its rich colouring, is typical. Its references to landscape with hill-like curves and a sense of peering through a garden is also pertinent to her intentions. But primarily, and in a not dissimilar way to Nicola de Maria, this was a form of painting that had to be experienced as music with its rhythms, harmonies and colour contrasts.

The romanticism of such an approach has been taken further by the young painter Thérèse Oulton. In her painting *The Heart of the Matter* (Plate 75), stairs, caves and raging seas seem to emerge from the ectoplasmic writhings of blue-brown paint. But, though possessed of an immense ability to manipulate substance and surface, Oulton continually disrupts our expectations. Imagery and the torrents of paint that form the picture fail to join up. Rifts and chasms open up and our eyes cannot relax. For Oulton, such a disruption undercuts the

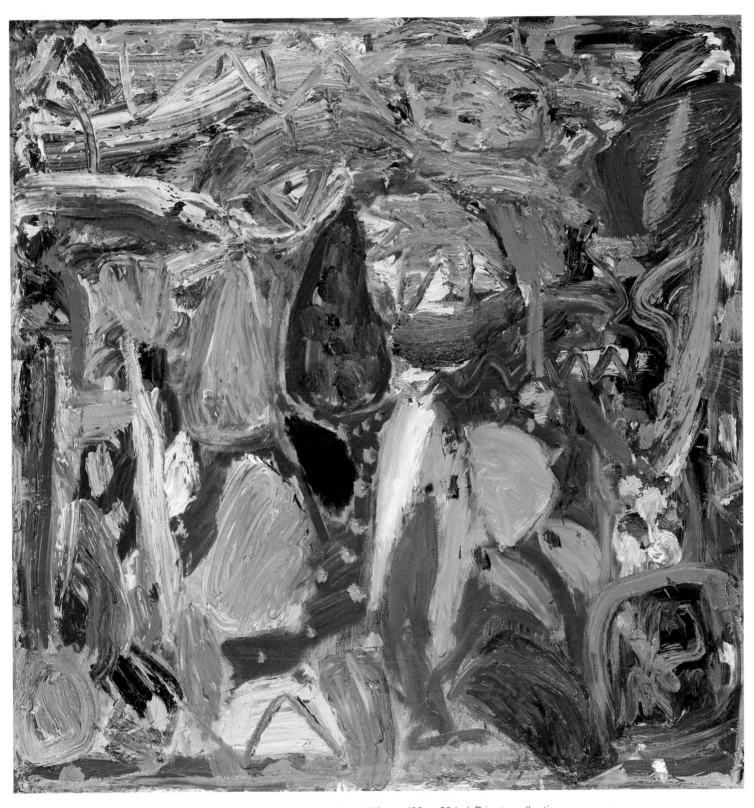

74. Gillian Ayres. *Venice and Neptune*. 1984. Oil on canvas, 152 × 152 cm. (60 × 60 in.) Private collection

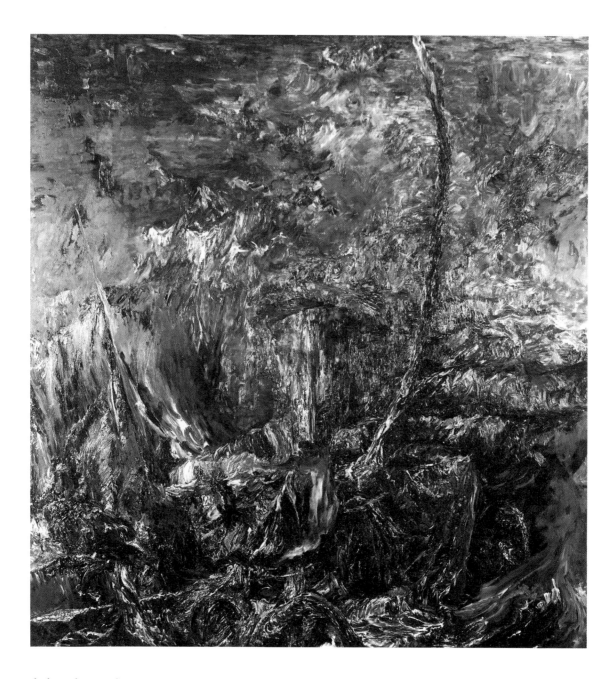

75. Thérèse Oulton. *The Heart of the Matter*. 1984. Oil on canvas, 242 × 228 cm. (95 × 90 in.) Private collection

too simple banalities of romanticism. She is not dissimilar from Volkar Tannert in her intentions.

For all their use of landscape motifs, both Ayres and Oulton remain essentially abstract painters: for them the paint itself must be made to generate its own meanings and, if necessary, images. Ayres' near contemporary, John Walker, had never been content with the limitations of abstract painting. Even in the sixties his large colour field paintings had included shapes that seemed to have the presence, if not the lineaments, of figures. His desire to incorporate figurative references into his pictures, while remaining an abstract painter,

reached its head in 1977 with his series of *Numinous* paintings (Plate 76). In these large pictures, shapes that seem substitutes for figures, sit or hover behind a balcony, a format that refers to specific precedents in work by Manet and Goya. Within the context of English painting at the time, it was a curious thing to do, but one which, in retrospect, allowed others to move away from the constraints of 'official' abstract painting. For Walker himself, it was a liberating move.

Soon after, Walker evolved a shape from Goya's portrait of the Duchess of Alba. This *Alba* shape – which was a bit like a squeezed carton – carried some of the associations of a person while remaining an abstract form. He continued to

76. John Walker. *Numinous VII*. 1975–8. Mixed media on canvas, 304 × 244 cm. (120 × 96 in.) Private collection

use it after his move to Australia in 1980. The experience of the harsh Australian light and the cultures of New Guinea and the aborigines led him to an art that was more dramatic and rhetorical. When he returned briefly to England after two years, he came across one of the Alba paintings in his old studio and added a skull to it, an act that was indicative of the changes in his work. Under the impetus of primitive art, his paintings began to pose questions about death and existence, comparing the Western approach of visualizing the world with the more magical Oceanic way. His paintings brought together fragments of both worlds and asked us to unite them. They were intended as ceremonies in which the viewer reintegrated those 'primitive' elements that had been too long repressed. *Oceania X* (Plate 77), provides a vivid example of this: the ubiquitous Alba shape is pierced with arrows like Saint Sebastian; at its feet lies a skull and the prow of a Polynesian boat; behind is a backdrop with the words from Saint John: 'in truth in very truth I am the door'. But truth here is not Christ the shepherd, but these complex rituals of painting, which seek to integrate the subconscious, the imaginative and the primitive with our everyday lives.

Probably, however, the key pioneering figure in moving through abstract gestural painting towards a use of evocative and powerful imagery is Christopher Le Brun. As a student, he had made abstract paintings, a virtually mandatory expectation under the college regime. Only after he left college could he allow images to slowly emerge from the broad horizontal swathes of his paintings. The most constant of these images was the horse. Often, as in *Pegasus* (Plate 78), it was winged and flying, leaping like an implosion from the mythical unconscious.

In a recent interview, the painter Malcolm Morley said he left England for New York partially because the English refused to talk about the effects of the 'unconscious' in art, or the way in which one comes to know it through art. Le Brun, and others, try to bring the subconscious into the open through their use of expressionist gesture and evocative imagery. The *Pegasus* horse image, with its associations of nobility, inspiration and active sexuality, is not an illustration to a preconceived idea but a naturally-occurring image in the activity of painting which can only exist there. It is the special relationship which this type of painting has to the subconscious (or preconscious) which makes it provocative.

Other of Le Brun's early paintings were often landscapes, but landscapes of poetry and reverie rather than of observation. In his drawings, such as *25.3.80* this is especially true: the lines (as in an automatic drawing) scurry back and forth searching until a vision of trees and sea and mountains is born.

If Baselitz seeks the hero of the age in the rebel and Clemente in the traveller, Le Brun seeks him in the poet of the imagination. In *Crimson Angel* (Plate 80), the winged figure is a poet, one who, like Apollo or Orpheus, wears laurel leaves around his head. Scarcely distinguishable from the grey-blue ground, he is poised above the abyss, his wings raised and coloured a flaming red, the colour of passion. But we are encouraged to read the painting meditatively, slowly. Le Brun may give us images of passion and potency, but he asked that we absorb them in a calm, and unironic, mood of contemplation.

77. John Walker. *Oceania X*. 1982. Acrylic on canvas, 213 × 171 cm. (84 × 67 in.) Private collection

78. Christopher Le Brun. *Pegasus*. 1981. Oil on canvas, 188 × 163 cm. (74 × 64 in.) Private collection

The same is true of Le Brun's contemporary Andrew Mansfield, though the latter's imagery is more odd. In the recent *Painting with Floral Curtain* (Plate 79), which he did after flying back from America, a curtain flies up against fields seen from above; the curtain is scattered with blue and white flowers and three violet spheres hover beside it. It is a curious and rich image conceived and painted with unobtrusive freedom, indeed, his flowers are as unrealistic as Le Brun's horses. Just as in Baselitz or Le Brun the abstract facture of the background is crucial, so here it is the beautifully modulated greys and purples of the sky that carry the emotional charge.

In direct contrast to such intuitive use of imagery are the paintings of Stephen McKenna, which have elements in common with Italian *anachronistici* paintings. His *Destruction of Actaeon* (Plate 82) is based on a Greek sculpture of the fifth century B.C. and is painted solely in greys and light browns. It is a static image with strangely stiff figures. Although his work refers consciously to Poussin or Titian, one is not so much engaged by or involved in his paintings as one would be in their work. He holds the viewer at arm's length, rather over-conscious of the stylization, an aspect that is a direct influence of de Chirico's late work. Like so many of his paintings it is phrased, as it were, in quotation marks. But this aloofness, which makes us as much an observer of art as an archeologist is of the past, is deliberate. Scenes of eternal struggle and beauty are held up for

critical appraisal rather than for sensual engagement. Here, painting is a tool for surveying myth and history.

A less cerebral and more wilful approach is taken by a group of young Glaswegian painters, of whom Steven Campbell and Adrian Wiszniewski are the best known. In Wiszniewski's pictures, a fretwork of lines describes an innocent landscape in which melancholy young men blow horns or are caught in whimsical daydreams. Even his *Gamekeeper* (Plate 83) is a young man, resting beside the river with a blue bird in his arms. As if by the power and grace of his poetic reverie, a large flower blooms before him. But Wiszniewski's work is not mere indolent escapism: it is an attempt to unite the past with the present and our present lives with all that has been lost. This intention is most apparent in his paintings about an imaginary Jewish brother, a representative of what he has lost through his parent's exile from Poland.

If many of Wiszniewski's images seem derived from children's picture books, Campbell's seem to come from the illustrations to old-fashioned boy's adventure stories. His men dressed as boys and his hikers with their cumbersome limbs travel through a world in which cause and effect have been turned topsy-turvy. The world of inanimate objects come alive. In one painting a building accuses its architect of bad design, a hundred fingers pointing out from its bricks. In *Fern's Revenge – Pool* (Plate 1) the unwitting hiker hurtles to

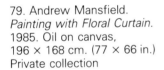

79. Andrew Mansfield.
Painting with Floral Curtain.
1985. Oil on canvas,
196 × 168 cm. (77 × 66 in.)
Private collection

80. Christopher Le Brun. *Crimson Angel.* 1983. Oil on canvas, 213 × 152 cm. (84 × 60 in.) Private collection

81. Steven Campbell. *Discovering Insects in a Herbaceous Border*. 1985. Oil and gouache on paper, 300 × 226 cm.
(118 × 89 in.) Private collection

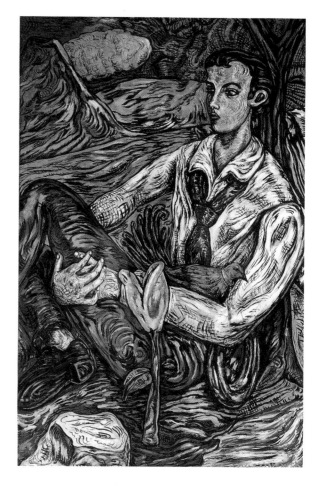

destruction in a dried-up swimming pool, tripped by a vengeful fern. But the marvellous humour of Campbell's paintings can conceal their seriousness, for they represent voyages into the mind's interior, a search for identity. In the side panels of *Discovering Insects in a Herbaceous Border* (Plate 81), hikers on just such a search struggle through a landscape whose elements are prepared to fall on or upturn them. Strangers in a world they have not made, they continually find that the world is, however, made in their image: when one hiker finds a ruined building, there is a vast painting of a hiker on one of its walls. For all their absurdity, Campbell's figures are heroic, and the nature of their endless search can be seen as a parallel to the search on which the painter has embarked.

Stephen Farthing, a young English painter, has for the most part confined his search to the rooms of his own house. At least ostensibly, for until recently all his paintings were of interiors – but of interiors where space was continually disrupted by shifts in scale and style, and by the way inanimate objects (chairs or pianos) would take on a strange and sometimes threatening significance. As a strategy, this was not dissimilar from Walker's, but the humour of these distortions and the underlying metaphor of the room as the human mind or memory makes these very different pictures. In *Word and Shelf* (Plate 84), a drinking pot hovers in the air. With its quirky play on different types of representation and on the life with which we invest objects, it is an elegant but disturbing painting. If these figurative artists attempt to tell us who

82. Stephen McKenna. *The Destruction of Actaeon*. 1983. Oil on canvas, 200 × 150 cm. (79 × 59 in.) Private collection

83. Adrian Wiszniewski. *The Gamekeeper*. 1985. Pastel on paper, 152 × 102 cm. (60 × 40 in.) Private collection

we are or who we could be – attempt to give us icons of the twentieth century – then landscape artists try to tell us how to experience the world and how to live in it. Artists such as Kiefer, Kirkeby or Cucchi lead us to a different understanding of the landscape, not as a place of pastoral escape, but as the battleground of our cultural and physical life. Generally, their work is not about seeing it as one, uninvolved and passing by, might through a train window, but about experiencing it and, in Wyndham Lewis's phrase, making it NEW again.

It is surprising, bearing in mind the central position that landscape used to have in English painting and how persistently its influence remains on abstract painting, that in recent years so few English painters have chosen it as subject matter. Although other painters are now turning to it, including Farthing, Ian McKeever alone has based his career around its representation. A self-taught artist and one-time professional footballer, he has been creating art based on the landscape since 1971. Given the decadence of the English landscape tradition, it was inevitable that his work should begin as an assault on its stale preconceptions. In his opinion, most recent landscape painting and our habitual attitude to landscape, was 'to do with a searching for union and communion with nature, with a sense of spirituality, and a feeling that the sense of the sublime can be held and transmitted through landscape. Such things are fictions'.

84. Stephen Farthing. *Word and Shelf*. Oil on canvas, 152 × 217 cm. (60 × 85 in.) 1984. Private collection

85. Ian McKeever. *Gleann Doire Dhubhaig*. 1985. Oil and photograph on canvas, 250 × 224 cm. (98 × 88 in.) Private collection

86. Christopher Le Brun. *Portrait of L. as a Young Man.* 1984-5. Oil on canvas, 198 × 173 cm. (78 × 68 in.) Private collection

He has also said that 'People do not actually participate in the landscape anymore, they no longer have a reaction to it on an experiential level; they react to it through a series of cultural filters which "show" them what landscape is about.' The key word is *participation*. His paintings are an attempt to destroy such 'filters' or expose them, and to make the viewer experience the landscape as a set of processes or activities rather than an immutable concept.

McKeever spends long periods living in isolated and wild parts of the countryside making sketches and photographs. A black-and-white photograph from one such camping expedition to the Isle of Skye is the support for the painting *Traditional Landscape No. 13 – The Needles*. To avoid too facile an interpretation as a 'romantic' vista, he layered it with gestures of blue and red paint. Though his work is often strikingly beautiful – as for instance *Gleann Doire Dhubhaig* (Plate 85) with its subtle nuances of blue and pink and delicate filagree of paint – the easy pleasure of the landscape prospect is always disrupted. The interplay of photograph and paint is always so balanced that we are never fully seduced by one alone; we are too conscious that it is partly a photo and partly a painting.

Another important difference between traditional landscape painting and McKeever's treatment of the genre is that his compositions do not attempt to master or to control the scene, but rather to create patternings across it. Drawing and painting are likened to the processes of nature – rain, snow, wind – which similarly create texture and patterning. It is by an involvement with these activities and patternings that he hopes to lead the viewer to a more dynamic understanding of landscape.

McKeever's landscapes, like those of Kirkeby or Kiefer are curiously empty of people. If the challenges of New Painting are to create figures to which we can relate and landscapes that we can experience anew, the ultimate challenge must be to put the figures back into the landscape. In formalist terms, this can be seen as a figure-ground problem – how to unite motif to background. Philosophically, it is a problem about our relationship to the world.

In a few recent works by Christopher Le Brun, he has begun to paint figures in his landscapes, albeit broadly conceived and drawn. *Portrait of L. as a Young Man.* (Plate 86) shows a drummer boy against a hillside. He is more sharply defined than all behind him, as if the drum were a symbol of art and as if he were drumming the world into existence. We should not make too much of this – after all, L. stands for Luke, his newborn son – but this is where the image and the activity of painting cohere. In the junction of material and meaning that can constitute painting, we reinvest the world with poetry and knowledge.

It is just such a reinvestment that many young painters in Britain, as elsewhere, are taking as their goal. The young, one-time abstract painter, Adrian Searle is representative of them. In his painting *Trust us* (Plate 87), it is as though a naked figure has been born of the washes of paint with which he begins each painting – Promethean-like, the figure looks around, waiting to rediscover his world.

5 ━━━━ THE DEATH OF THE SCHOOL OF PARIS

'La figuration libre' is to do what one likes as much as possible. 'La figuration libre' is to amuse oneself, to be cool, to, as they say in English, 'have fun'.

Robert Combas

In Paris, throughout the seventies, the artist's group *Support/surfaces* maintained a stranglehold on painting. The avant-garde had been institutionalized around the production of reductive but elegant abstractions by artists such as Marc Devade and Daniel Dezeuze. These were seen by non-believers as being little more than warmed-up leftovers of New York painting, served up with exotic intellectual dressings. Formalist criticism and Lacanian psychoanalytic theory, in particular, were ransacked by writers like Marcelin Pleynet to create justifications. It was Modernism at its most pretentious and boring.

Support/Surfaces seemed the nadir of the school of Paris, that tradition which could trace itself back through Cubism and Impressionism to the seventeenth century. To many observers it now seems probable that it was in fact its last undistinguished chapter: since 1980 waves of protests, mainly from the provinces, have battered it down from its position of prominence with astonishing ease – and few regrets. These waves were dominated by the young anarchic artists associated with the term *figuration libre* (free figuration) who came from the provinces and had first exhibited in Rennes or Saint Etienne. Symptomatically, the self-proclaimed leader of *figuration libre*, Robert Combas, came from a working class family on the south French coast. When he finished his foundation course at college he felt that he could at last rebel against his childhood of repressive schooling and against his doctrinaire *support/surfaces* professors. At last he was able to be himself: 'I was FREE. From that freedom I decided to do a completely new art, liberated from all constraints: the story of an average kind of bloke, and sometimes even less than average.' His resulting work was rumbustious and gloriously vulgar, filled with cartoon and graffiti-derived figures. The over-sexed gunner of *On the Road from Mezes . . .* (Plate 89) with his hairy legs and triangular body is a typical lord of misrule and emblem of unrestrained desire. In his 1984 painting *The Colonel Barabe* (Plate 90) a number of such triangular creatures are attacked by a right-wing bogeyman (dressed as a gendarme) who has every intention of eating them for dinner.

88. Robert Combas. *Thousands of Beasties and insects are avidly searching for the photos of the 'Hidden Stars Game'. Ketty relaxes on a patch of grass while firing a revolver in the air. A transparent cowboy walks about with one foot in a pot of 'A LA CON' paint, while a smoker of American cigarettes passes by. In the corner abstract sculptures decorate the scene and in the top right hand corner one can see the nonsense word 'BARBEUSIER'.* 1984. Various paints on canvas, 200 × 333 cm. (79 × 131 in.) Private collection

89. Robert Combas. *On the Road from Mezes* . . . 1983. Mixed media on canvas, 127 × 244 cm. (50 × 96 in.) Private collection

90. Robert Combas. *The Colonel Barabe* . . . 1984. Mixed media on canvas, 236 × 180 cm. (93 × 71 in.) Private collection

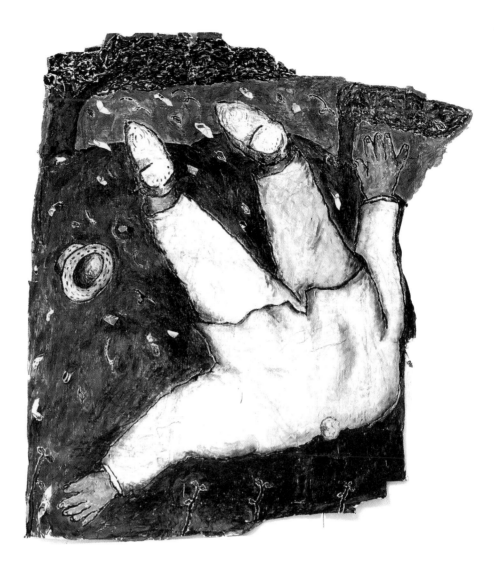

91. Jean-Charles Blais. *Fall from the Nest*. 1983. Acrylic on torn posters, 260 × 230 cm. (102 × 91 in.) Private collection

Combas creates primitivist figures to defend them and their liberty. Combas was only twenty-five when he made the painting: it is a young man's art, like Alfred Jarry's *Ubu Roi*, full of energy and smut, cocking a snoot at the authoritarian and dreary.

Combas's paintings are full of devices from cartoons: narratives, jokes, and reappearing characters like the colonel, the triangles and the sexy Ketty who is at the centre of *Thousands of Beasties and Insects . . .* (Plate 88). That painting presents a comic strip world where energy, not control, is the determining factor and where a photograph of Combas himself grins down on the resulting healthy cacophony.

Bandes dessinées, the French comic books, are a shared source of inspiration for all these young painters, as is the quirky but imaginative work of the artists Christian Boltanski and Ben Vautier, who invented the term *figuration libre*. They have also been influenced by the Italian *Trans-avantgarde*, but have eschewed the poetic quality of the Italians in favour of a popular, vernacular art. Indeed, for the time being, Combas and his associates wilfully oppose the very notion of high art, despite making a living from its galleries and markets. No wonder Hervé Di Rosa, Combas's closest accomplice whose work is even

92. Louis Cane. *Meninas*. 1984. Oil on canvas, 230 × 230 cm. (91 × 91 in.) Private collection

closer to cartoons, should mockingly ask: 'If they discover one day that its a hoax, what would become of me? I tremble at the thought. Yes, what would I do if they realise that it's not painting at all, but only COMIC STRIPS?'

Jean-Charles Blais, born in 1956 in Nantes, is less dependent on cartoons for his imagery, which is normally centred on pin-headed characters who stride across the world as though on an endless quest. Like Steven Campbell's hikers, they are amiable, not very bright and totally bemused. But despite their ridiculous clothes, and the numerous accidents that befall them, they are serious, even tragic figures; often there seems to be a discrepancy between them and their grossly physical bodies and existence. In *Fall from the Nest* (Plate 91) a vast baggy suit tumbles through the air, its hat falling off to join the dead, autumn leaves; out of its collar appears a tiny head; it seems more like the pilot of a plane than the person who would own and fit this suit.

The very activity of painting is central to Blais: 'I had the idea of painting everything on anything: cardboard, tins, pieces of wood, packing-papers, coal-scuttles, curtains, posters, without stopping.' Just as his figures are rediscovering the world by walking all over it (Plate 93), so he tries to do the same by painting all over it. Most of his paintings are made on posters torn from the subway which have been endlessly repasted and covered up. The images are both drawn over and into these strata. In *Fall from the Nest* the head rests in a hole carved from the posters. Just as the Everyman of his pictures walks through archetypal forests, so his painted image travels through remnants of his culture.

Even some of the *Support/surfaces* artists have shifted to a more figurative way of working. Indeed many of them, faced with the cul-de-sac that

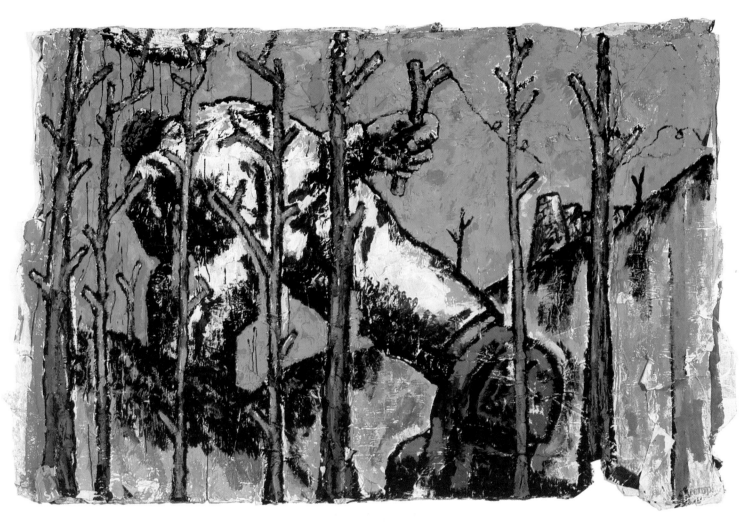

93. Jean-Charles Blais. *Untitled*. 1984. Acrylic on torn posters, dimensions unknown. Private collection

their forms of abstraction had become, had begun to do so before the emergence of the younger painters. Louis Cane, one of the founding members of *Support/ surfaces*, was already including traces of figures in his paintings by the late seventies, just as was John Walker across the channel. But Cane is a far more self-conscious artist than Walker: whereas Walker struggled to create a language between abstraction and representation Cane pilfered art history to make syncretic, violent and often portentous paintings. His *Meninas* (Plate 92) of 1984 is representative: it is based on Velazquez's *Las Meninas* or *Maids of Honour*, but treats its model with far less reverence than even Picasso's variants of the painting. The expressionism and aggression of his approach is shown by the spattered paint and the distortions of the female forms. But behind that lie the recurrent features of *support/surfaces* art: an intellectual obsession with art and

94. Gérard Garouste. *The Constellation of Sirius*. 1982. Oil on canvas, 250 × 300 cm. (99 × 118 in.) Private collection

95. Jean-Michel Alberola. *The Flesh of Susanna.* 1982. Oil on canvas, 195 × 195 cm. (77 × 77 in.) Private collection

its forms (hence the play with the picture frames), and strangely decorative colouring. Cane's pictures lack the populist energy of Combas or Blais; their appeal to primitivism is self-conscious rather than instinctive.

Gérard Garouste, who began as a Conceptual artist, uses past art too, but with a loving irony. Ostensibly his intention is similar to that of the *Anachronistici*, using old imagery as a way of examining the condition of painting. But the sensuality and obsessiveness of his paintings suggests that he takes his visions more seriously than he admits. Like Thérèse Oulton, who uses paint in a similarily ectoplasmic way, he is fascinated by alchemy and its goal of transformation, both material and spiritual. His early drawings, paintings and sculptures were filled with alchemical symbols.

In *The Constellation of Sirius* (Plate 94), with its echoes of Tintoretto and El Greco and its treacly brown paint, Garouste sets out to confuse us, to give us puzzles. Not only do we attempt to discover the narrative of the painting, but we begin to question our own uncertain response. Recent paintings, such as *The Argument* (Plate 96), have become even more difficult to unravel. What is the argument about? Who is the woman? Why are the figures so elongated? We are at once seduced by the bravura painting and disaffected by the hermetic message that its narrative purports to tell but does not.

What Garouste's work *does* have in common with Blais and Combas is its use of quotations, albeit in his case not from the contemporary world. These French artists seem to belong to a culture of quotations; they make up their existence from the pictorial fragments around them. Of no one is this more true than the young artist Jean-Michel Alberola, who was born in Algiers of Spanish

96. Gérard Garouste. *The Argument*. 1984. Oil on canvas, 295 × 250 cm. (116 × 99 in.) Private collection

97. Jean-Michel Alberola. *Susanna and the Elders: a Civil Painting like a Civil War (dedicated to Durruti).* 1985. Oil on canvas, 200 × 230 cm. (79 × 91 in.) Private collection

parents and brought up in Le Havre. Partly as a result of such an unsettled past, he is obsessed with the fragmented nature of contemporary culture and consciousness. His paintings revolve around the stories of Susanna and the elders and the death of Actaeon, in both of which the 'reward' for seeing a naked woman is death. Seeing, with such fatal consequences, is, to Alberola, a symbol for the act of comprehending truth itself. In *The Flesh of Susanna* (Plate 95), it is we who become the elders gazing voyeuristically at the fleshy Susanna (a figure derived from Tintoretto). The fact that she herself looks at her own image and that the drawing of her body is deliberately unfinished, short-circuits our expectations and pleasure. Always Alberola shows the world as being disrupted and incomplete.

It is difficult to think of any artist who puts so much arcane information into a picture as Alberola. A recent painting, *Susanna and the Elders: a Civil*

98. Vincent Bioulès. *The Viallat at Home.* 1981. Oil on canvas, 190 × 250 cm. (75 × 98 in.) Private collection

99. Ger Van Elk. *Oahwilliwhao (Wall's Ice Cream).* Acrylic and colour photograph on canvas, 104 × 350 cm. (41 × 138 in.) Private collection

Painting like a Civil War (dedicated to Durruti) (Plate 97), is typical of his theoretical and hermetic bent. Just as in Polke or Salle disparate objects and styles are yoked together, but here they are filled with secret meanings. The groups of eleven dots on the right represent his birthdate, the eleventh of January, regarded as an astrologically unstable day. As always his 'signature' ΛCTEAON FECIT has an A with no crossbar to indicate his own incompleteness. The relationship of the crucifix shape and the spiral, the chair, the title and dedication to the Spanish anarchist remain obscure. Alberola's work is always intriguing, but despite his undoubted skills, it is getting more difficult, less 'painted' and more a cat's cradle of private symbols and ideas. Unlike the other artists associated with *figuration libre* he seems a probable victim of the over-intellectualism that has bedevilled recent French art.

It is difficult, however, to predict the future for these very young artists as they are such a recent phenomenon; the initial exhilaration of their energetic vulgarity has not yet worn off. What they have certainly done is restore verve and inventiveness to French art. In no one's work are such virtues so paramount as in that of the young artist George Rousse, who though technically a photographer rather than a painter should be mentioned here. In deserted and derelict buildings he will fresco enormous figures and incidents; the finished artwork is, however, not this, but large and beautiful colour photographs he takes of them. They are like records of a fictional world come alive in this one.

Paradoxically the future of French painting may involve some sort of rapprochement with *support/surfaces*. Beneath the deadweight of its theoretical speculations were some vital issues: ones we have encountered in considering New Painting: the power of materials, sexuality, the relationship of gesture and subconscious imagery. Perhaps the beginnings of such an approach can be seen in the work of Vincent Bioules. His painting *The Viallat at Home* (Plate 98), is an overt homage not only to Matisse but to Viallat, the most decorative of the *support/surfaces* painters and whose painting, with its habitually repeated palette shape is to the left of the picture. Bioule's may be a modest and unassuming painting, but it parallels *figuration libre* in its joyful response to life.

All across Western Europe indigenous schools of painting have begun to emerge, full of young artists who are aware of both international developments and their own vernacular traditions. The vitality and optimism of the recently re-awakened Spanish painting community is especially striking. Inevitably the long cultural isolation of the Franco era has left its mark, but the commitment of groups of painters in both Madrid and Barcelona is creating a more fruitful environment. Although still at the fledgling stage, the work of the Barcelona painters Ferràn Garcìa Sevilla and Miguel Barcelò is provocative and exciting.

Curiously Holland, the country which has most zealously supported its artists over the last few decades, is not home to any equivalent school. Painters like Rene Daniels and John van't Slot despite their wit lack the intensity of their German contemporaries. Perhaps a more major figure for New Painting is the apparently eclectic figure Ger van Elk. His games with the techniques of representation, which were for the main part photographic, were as serious; as indeed were his adaptions of seventeenth-century Dutch still lifes. But perhaps it was only with the hindsight New Painting gave that we could see how pertinent the evocation of physical existence in pieces like *Oahwilliwhao (Wall's Ice-Cream)* (Plate 99) was.

6 ■■■■■ NEW YORK – WHEN THE WORLDS COLLIDE

I want to be able to tell the world what it's like being an artist. It's not like cutting off your ear or hanging out in bars and drawing pictures of barmaids. It's a very sophisticated thing, very much like being a lawyer or doctor.

Robert Longo

Just as all roads once led to Rome, so now all roads in the art world lead to New York. For all the resurgence of Europe's art, the majority of art sales are made in New York. It may be considered as proof of the contemporary art boom in Germany that there are now nearly fifty commercial galleries in Cologne, but they are a drop in the ocean compared to those in New York, which number well over a thousand. There is more art to be seen there, more artists to meet and talk to and more publications to read than anywhere else. Art has attained an excitement and prestige in New York that it does not have anywhere else.

But it is a market. And a market where artworks are consumables and prestige possessions. A recent anecdote tells of one fashionable woman saying to another, while on their Saturday morning tour of SoHo galleries, 'I've got a Shafrazi, two Metro pictures, a Paula Cooper and all I need to make up a good collection is a Mary Boone.' They are, of course, names of famous galleries not artists. In a world in which a picture can be synonymous with Gucci handbags or designer jeans, it is inevitable that many artists should become, above all else, manipulators of an affluent and competitive system.

The charisma attached to New York's post-war abstract painting, together with the repute of its galleries and museums, made the city the automatic leader of every new trend. With its art of successive *avant-gardes* predicated on style and formal developments, the aggressive, anti-formalist and eclectic paintings of the New European painters came as a traumatic shock. It painfully exposed the lack of energy in most current New York art; but it did give a new perspective with which to view certain American artists as well.

Without a single group of dominant New Painters, the American scene may seem confused in comparison to the German or Italian. However, there are a whole string of developments that combine to show a shift into what we have termed New Painting. One could, if one was being contentious, see the beginnings in Jackson Pollock's series of difficult and challenging works of 1951–

4, in which elements of figuration started to reappear from his tangled skeins of paint. But the first real rupture was in 1970, when Philip Guston first exhibited his new cartoon-derived figurative paintings.

An important and long-respected member of the abstract expressionist generation, Guston's decision to show pictures similar to his untitled painting of 1969 (Plate 128) – in which a hand resembling a slab of meat draws a red smear on a wall – was to many people like hearing an archbishop blaspheme. It seemed a betrayal. But to Guston, the continuance of his old abstract style would have been a betrayal of his own inner self. It was no coincidence that these works had been preceded by a period of self-searching, during which he produced his most austere and minimal works. He had cut away the unnecessary decorations that abstraction, for him, had become and returned to that rag-and-bone shop of the heart that the poet Yeats wrote of in his late age.

Throughout the seventies, Guston produced an extraordinary body of images which featured all the flotsam and jetsam of life: old shoes, smouldering cigarettes and empty paint cans. When he painted himself, it was to picture himself in bed smoking, devoid of any features but an enormous eye, with a plate of french fries at his side; and behind that, the stuff of his life – a pile of junk and a naked light bulb.

Guston's late paintings were not so much *angst*-ridden expressionist outpourings, as many saw them, but innately classical celebrations that looked

100. Brice Marden. Installation of *Annunciation* paintings. 1978. From left to right: *Conturbatio, Cogitatio, Interrogatio.*

101. Malcolm Morley.
Madison Telephone Book.
1970. Acrylic on canvas,
84 × 68 cm. (33 × 27 in.)
Private collection

back to Poussin and Mondrian. His choice of cartoon-like simple forms arose not from vulgarity, but from a desire to monumentalize the everyday life, to assert the importance of the objects of this physical world.

Sleeping (Plate 102) is typical of both his palette – restricted to red and blacks – and of his lean drawing style. A pimply legged man huddles under sheets, only his earlobe and eye-lashes exposed. The pyramidical composition is, as always, assertive and direct. We can assume that he sleeps from exhaustion, to judge from his ratty hair and the fact that he is still wearing hob-nailed boots, but that he will awake vital and triumphant. It is such vitality that Guston's late paintings, with their raucous humour and unflinching gaze, celebrate. An old man, like Hokusai, crazy about drawing, he was pouring out the experiences of a lifetime, intent on sharing them.

Perhaps, paradoxically, a similar intention underlines the very different work of Brice Marden. He may have limited his production to monochrome canvases, but they were made in the context of a deep knowledge of the painting tradition and with the highest ambitions. It is his emphasis on both meaning and material that makes him important to New Painting. Although one may normally associate New Painting with the return to figuration, it is as important to bear in mind these two emphases. As Achille Bonito Oliva has said, it is not figuration but the figurable that is crucial: the drive to wrest meaning from the world.

102. Philip Guston. *Sleeping*. 1977. Oil on canvas, 213 × 175 cm. (84 × 69 in.) Private collection

103. Brice Marden. *Masking Drawing 4 (Red Drawing 4)*. 1984. Gouache, graphite, ink and oil on paper, 38 × 32 cm.
(15 × 12½ in.) Private collection

104. Robert Kushner. *Aida*. 1979. Acrylic and pencil on paper, 190 × 478 cm. (75 × 188 in.) Private collection

Marden, who had worked as Rauschenberg's assistant in 1966, sought to reinvest the most reductive forms with spiritual meaning. He worked his paintings in a series of layers of oil and wax and turpentine that seemed to capture extraordinarily precise sensations of colour and light, while their materiality was as exposed as Kiefer's or Rauschenberg's. He also sought constant references from outside painting to help clarify their latent meanings. For example, the *Annunciation* (Plate 100) series of paintings refer, however obliquely, to the five stages through which the Virgin Mary passed on receiving the archangel Gabriel: disquiet, reflection, inquiry, submission, merit. They are stages on a spiritual journey which the five paintings reflect by their changing formats and colours.

But it is not just the unrepentent idealism coupled with an emphasis on the materiality of painting that has endeared him to artists like Schnabel and Clemente; it is also the way in which he has placed a critical weight on drawing. Against the most austere of frameworks, a carefully adjudged repertoire of apparently chance marks will produce a character, a sense of drama. In his hands, a grid can become a window or a prison; there is an endless play on the open and the closed, on light and erasure. *Masking Drawing 4* (Plate 103) shows the way his work has become more complex, simultaneously lyrical and troubled.

There is constant talk of a 'return to abstraction' in New York. What is certain, is that such a return would be as much to a new type of abstraction, as the return to figuration was to a new type of figuration. Apart from Marden, who has been so influential to many new painters, and to the extent that he himself can be counted as one, other painters have shifted the course of abstraction. Most famous of these is Frank Stella, whose recent reliefs – concatenations of glitter and exotic colours on twisted shapes of aluminium – have broken all the tenets of Modernism. His shift to an 'eccentric abstraction' is paralleled in work by artists Stephen Buckley in England and Claude Viallat in France. Others, notably the

105. Brad Davis. *Water Scene.* 1981. Acrylic and polyester on canvas, 76 × 178 cm. (30 × 70 in.) Private collection

Irish-born New Yorker Sean Scully, extended the poetic resonances of minimal austere paintings. The Americans Elisabeth Murray and Bill Jensen use organic-looking shapes to give their paintings added presence.

The continued vitality of abstraction assures that the concerns of New Painting are not exclusively that of figuration. The activity of painting as a way of generating meaning and thereby mediating between figuration and abstraction was topical as well. This is especially true of the work of Malcolm Morley. Morley was brought up in England but left it in 1958, aged 27, for New York, where he has since remained. By 1966, he was seen as one of the leading Hyperrealist painters. But whereas most of that genre tried to replicate photographs as precisely as possible, Morley, when transferring the image to canvas, used a grid; he then treated each square of the grid individually so the marks functioned not mimetically but as independent gestures. By 1970, with his painting *Madison Telephone Book* (Plate 101), his exploitation of such accidents of the activity of painting had increased to the point where imitation and the psychological process of mark-making were in uneasy balance.

Through the seventies Morley's work became more imbedded in autobiography and a personal mythology. His representation of himself as a masked cowboy waving a dildo in his painting of 1979, *Christmas Tree – The Lonely*

106. Malcolm Morley. *Macaws, Bengals with Mullet*. 1982. Oil on canvas, 305 × 203 cm. (120 × 80 in.)

107. Robert Kushner. *Untitled*. 1985. Cast paper, 75 × 202 cm. (29½ × 80 in.) Private collection

Ranger Lost in the Jungle of Erotic Desires is typical of both his sense of humour and his forthrightness: riding a toy horse, he is lost in a Sears and Roebuck jungle of toy trains, Red Indians, women's legs, parrots and unconvincing foliage. It is out of such diversity that he has constructed an iconography for himself.

But it is the way that Morley converts the world into paintings that is of most importance, something that he has developed further in the eighties by his use of water-colours, which are enlarged by his grid system into much bigger paintings. There is the same compression and dislocation of objects, but the results are more joyfully coloured, more frankly decorative. This is true of *Macaws, Bengals with Mullet* (Plate 106), one of his most successful recent paintings. It is a decorative vision of nature before The Fall where tigers indolently lie under a tree which hovers above a teeming sea. As often with his images, they are scrambled like jottings of a travel diary, half destroyed by that very act which brings them to life again. The paintings seem to be endless acts of negotiation with a world that will never come into focus.

Throughout the seventies, as the impetus of Formalism and Minimalism petered out, the New York art scene diversified and a long series of new tendencies began to emerge. The most important of these, for painting, were 'Patterning and Decoration' and 'New Image painting'. The Pattern and Decoration artists denied the very exclusiveness of high art. To them a piece of wallpaper, a patchwork quilt or an item of clothing could be more creative than a formalist painting or piece of minimalism – in fact was probably more so. Like many post-war tendencies, it began as an assault on the fetishization of the art object, and as an attempt to democratize Art again. Admittedly, a good deal of

108. Neil Jenney. *Them and Us*. 1969. Acrylic on canvas, 148 × 331 cm. (58 × 130 in.) Private collection

their exuberant work, with its use of commercial fabrics and patterns, quickly became fashionable and expensive, the latest form of radical chic. But the free-wheeling attitude it adopted toward form, style and the use of sources was invigorating.

Robert Kushner was the central figure in this movement. From 1971 he was constructing a decorative style, but not until he travelled to Iran in 1974 did he realize that just as there was no distinction between decoration and art in Middle Eastern culture, so there was no need for it in the West. Like his friend Kim McConnel, he was prepared to make furniture and design interiors, but his real instinct was to revivify painting by approaching it from a new angle.

By 1977, Kushner was integrating figures into his brilliant surfaces of collaged and over-painted fabrics. His large painting, *Aida* (Plate 104) – with its Busby Berkeley-styled Egyptian chorus line drawn over geometric fabrics – might appear kitsch, but the fluent, witty drawing gives it an impact and effect far beyond that. When he said, 'I prefer bad drawing as it gives the face more character', he was being disingenuous. He draws with deliberate freedom rather than ineptitude. Indeed his drawings sometimes represent sexual freedom, as in his series of erotic illustrations to books by Kathy Acker.

In his search for an art that would express happiness or joy, Kushner has increasingly turned to Matisse and Dufy. While art of the eighties has often

109. Susan Rothenberg.
United States II. 1976. Acrylic and tempera on canvas, 192 × 229 cm. (76 × 90 in.) Private collection

110. Brad Davis. *2 Pines Study #1*. 1984. Acrylic on canvas, 132 × 142 cm. (52 × 56 in.) Private collection

111. Neil Jenney. *Window No. 6*. 1971–6. Oil on canvas, 110 × 146 cm. (43 × 57½ in.) London, Saatchi Collection

seemed obsessed with aggression and *angst*, he has calmly continued to celebrate life, not only for its sensuality but for its spirituality. Over the years his use of line and fabric has grown more complex and has recently been paralleled by works on coloured cast paper. In the one illustrated here (Plate 107) an odalisque looks back at the viewer as though she is outside time; she glows with an inner contentment, no doubt representing the joint goal of art and religion.

Another artist associated with Pattern and Decoration, Brad Davis, made pastiches of Persian or Indian miniatures in the late seventies. But pastiche can be a serious procedure. A painting like his *Water Scene* (Plate 105) of 1981 is not so much ironic in its use of a past style of painting, as a conscious attempt to absorb its spirit. Here also, as in Kushner, the loose drawing is evidence of a free and relaxed attitude to the world.

Pastiche was also used as a way of learning how to paint well, a fact that Davis demonstrated recently with some marvellous landscape paintings, based partly on Chinese calligraphy and partly on abstract gesturalism. Now in his early forties, Davis had left New York for Colorado in 1983. Beset by illness, he adopted as his motif the pine trees, which in Chinese art stand for perseverance. *2 Pines Study* (Plate 110), has the familiar New Painting emphasis on motif against a nearly abstract background, together with a sense of poetry and immanence. Made in the studio, recreating emotions and sensations, these are

112. Julian Schnabel. *Painting for the Salvation of Ross Bleckner's Leg*. 1979. Oil on canvas, 244 × 214 cm. (96 × 84 in.) Private collection

113. David Salle. *His Brain*.
1984. Oil and acrylic on
canvas, 297 × 274 cm.
(117 × 108 in.) Private
collection

not paintings about observations of the landscape but about the experience of it. Although they lack the mythic and historical references we find in Kiefer or Cucchi, they are for this period uniquely convincing pastoral paintings. They give a unified vision in opposition to the cultural dislocation of the age.

The 1979 exhibition at the Whitney Museum *New Image Painting*, gathered together some of those artists who had concentrated on figurative motifs, including Nicholas Africano and Lois Lane. Their precursor had been Neil Jenney, who around 1970 painted a whole series of canvases that isolated one or two objects or figures and, surrounded them with apparently mindless, arbitrary brushmarks, as in *Them and Us* (Plate 108).

Whilst these earlier paintings, with their combination of emotive image and inexpressive marks were to be influential for others, Jenney himself went in a different direction. More recent paintings present immaculately portrayed landscapes presented in elaborate, inscribed frames. *Window No. 6* (Plate 111), for instance, depicts a few branches with spring buds; in the background a curious ice cube-shaped cloud floats by. Such unsettling juxtapositions are common. It is part of his concern with how we receive images, playing games with our expectations, as the earlier, deceptively guileless paintings did in a different manner.

114. Julian Schnabel. *King of the Wood*. 1984. Oil and bondo with plates and spruce roots on wood, 305 × 594 cm.
(120 × 234 in.) Private collection

115. David Salle. *Very Few Cars*. 1985. Oil on lead and wood, 199 × 269 cm. (78 × 106 in.) London, Saatchi Collection

The horse paintings made by Susan Rothenberg in the mid-seventies were also included in the New Image exhibition. They were simple side views of horses, often bisected by a cross or else divided by the painting into two distinct colour zones (Plate 109). Their image seemed drained of any real meaning. Yet there was still a curious presence to them, as if behind the schematization there was a potency waiting to emerge.

Also in 1979, Julian Schnabel had his first New York exhibition at Mary Boone's gallery. Within two years, he was being hailed as *the* American painter of our time – few artists have had such instant fame and success. The speed with which he became a media star and the publicity that continually surrounded him have led many to condemn him as mere hype. When Schnabel left Mary Boone for the Pace gallery it was reported as emotive an event as Mick Jagger leaving the Rolling Stones. His career and life – as does Salle's or Haring's – hold the same media interest as a film star's. Similarly, when Clemente, Warhol and the East Village prodigy Jean-Michel Basquiat 'announced' they were making collaborative paintings, they were regarded more as a rock 'supergroup' than serious artists. When the artist Jennifer Bartlett was interviewed by a glossy magazine her photograph appeared on the cover – with prominent credits given to her hairdresser and make-up artist.

But Schnabel is an interesting and important painter, though it is sometimes difficult to actually see his paintings through the publicists' smoke-screens. *King of the Wood* (Plate 114), his large painting from 1984, can stand as the epitome of his work. In it, several hundred plates and bits of shattered crockery are stuck on six panels that stand out from the wall by several inches; over the plates, trees are painted in long dragged marks and a cloaked and crowned figure stands, holding a drawn sword; to either side of him are large pieces of tree root that sprawl out from the dishevelled picture surface. The figure represents the priest-king of the wood at Nemi, a sanctuary of the goddess Diana. The golden bough taken by Aeneas into the underworld for protection supposedly came from that sacred tree. The legend continues that should a

116. Robert Longo. *Still.* 1984. Acrylic on silkscreen on wood; charcoal and graphite on dyed paper; oil and copper leaf on hammered oak; granite and metal; oil on hammered lead, 248 × 732 cm. (98 × 288 in.) Private collection

117. Keith Haring. *Untitled*. 1982. Vinyl ink on vinyl tarpaulin, 365 × 365 cm. (144 × 144 in.) Private collection

runaway slave break a branch from that tree, he might challenge the king to single combat and, if victorious, take his place.

Schnabel, as he does in other works, presents us with a mythical figure, a skeletal guardian of the dead discovered in a mess of materials. Indeed, his paintings resemble archeological sites with their broken pots and ghostly traces of people and are often painted in the putrescent colours of the dead and dying. Like Kiefer's paintings, *King of the Wood* is a corrective to the large colour field paintings of Barnett Newman, Morris Louis and American artists of the sixties; rather than surrounding us with sensations of colour, we are overwhelmed by material and associations of myth, history and literature.

Many of the paintings that Schnabel exhibited in New York were more whimsical; *Painting for the Salvation of Ross Bleckner's Leg* (Plate 112) for instance, in which the remnant of a classical torso, a couple of T bars and a painter's palette jostle each other around a niche of the type that held a household god in a Roman home. Here, and elsewhere, there is a sense of emptiness in Schnabel's work; however much he gathers objects together, they do not connect. As his eulogists say, he is the poet of a hollow world.

Schnabel strives, however, to make sense of it all. His work has been marked by its use of chance – when he made ink drawings in 1981 (Plate 2), he did so in the rain, allowing the raindrops to splatter across the paper – and apparent arbitrary juxtapositions of images and materials. His baroque extravagances and extreme methods include enlarging a small object or reproduction with an enormous three foot brush; as the brush hits his plates, it is buffeted from side to side; if the picture is on velvet, as many are, the brushes catch in the pile, creating

118. Jedd Garet. *What the Earth is Really Like.* 1984. Acrylic on canvas, 267 × 213 cm. (105 × 84 in.) Private collection

119. Keith Haring. *Untitled*. 1984. Acrylic on muslin, 152 × 305 cm. (60 × 120 in.) Private collection

more erratic paintwork. When asked why he used such a mixture of aggressive and chance-ridden techniques Schnabel replied that he relied on 'blind faith'.

The great Abstract Expressionists, from Pollock to Still, had made an act of faith in their materials central to their art. That is not something that many artists in this irony-laden age are totally prepared to do now. By making such a claim, Schnabel is taking over Pollock's heroic mantle despite all his dilletantism and playboy life-style. In his paintings he attempts, like Aeneas, to enter the underworld of the imagination in order to bring back truth. This is the rhetoric of power. Part of the reason for the shock effect of his paintings (with their fantastically overworked surfaces and grandiose gestures) is to dominate us with *his* vision. The appeal and repulsion we sense in his work is to do with power: the power to absorb every material and every image and turn them into *his* vision, *his* art.

But such untrammelled ambitions are vitiated by the uneveness of his work. For all his mythic pretensions he is often at his best when working abstractly, welding gestures to material with verve and dexterity. The claims that he is America's answer to Baselitz or Kiefer have yet to be substantiated. His work does not have that consistent and coherent sense of culture and history which gives their work such richness. It is indicative of his gadfly knowledge that the information for *King of the Wood* is all conned from the first three pages of Fraser's *Golden Bough*. He has not lived the myths that he uses.

In spite of their friendship and collaborations, Schnabel and David Salle can be seen as opposites. In fact, Salle is often seen as the 'classicist' compared to Schnabel the 'romantic'. Whereas Schnabel tries to fuse images together in the crucible of his personal style and genius, Salle holds them carefully apart. For

120. Kenny Scharf. *When the Worlds collide.* 1984. Oil, acrylic and enamel on canvas, 310 × 610 cm. (122 × 240 in.) New York, Whitney Museum of American Art

him originality is, he says, 'located outside this question of personal "style". Put simply, the originality is in what you choose. What you choose and how you choose to present it.' He gives us a new way of seeing what already exists in the world, not what could be in a better one.

To his college contemporary Eric Fischl, Salle's importance is in having, 're-stated for his generation the whole thing about the meaningfulness of meaninglessness. David so clearly stated the problem, the way he handles images and meaning where things don't add up. He puts the image out there as if he were talking only in nouns. The nouns call up things, but they don't connect.'

His Brain (Plate 113) presents us with just such a collection of unconnected 'nouns': paint is smeared down a printed fabric; a naked woman, drawn in the style of a commercial illustrator, bends over; four identical profiles of a man are stencilled across her buttocks; a quickly drawn, thoughtful woman and a messily painted houseboat complete the conundrum. His mixture of contradictory styles and modes of representation bears obvious similarities to that of Sigmar Polke.

Salle's work often raises hackles. To feminists, his constant use of images of women in sexually available poses is gratuitous and offensive; to them, he is only selling soft-porn masquerading as expensive New Wave art. To purists, he is not even a painter, only a tracer – and not even a good one at that! His frequent use of quoted illustrations recently rebounded on him when he was

121. George Condo. *The Great Schizoid*. 1984. Oil on canvas, 150 × 200 cm. (59 × 79 in.) Private collection

122. Kenny Scharf. *Juicy Jungle*. 1983—4. Oil on canvas, 221 × 256 cm. (87 × 101 in.) Private collection

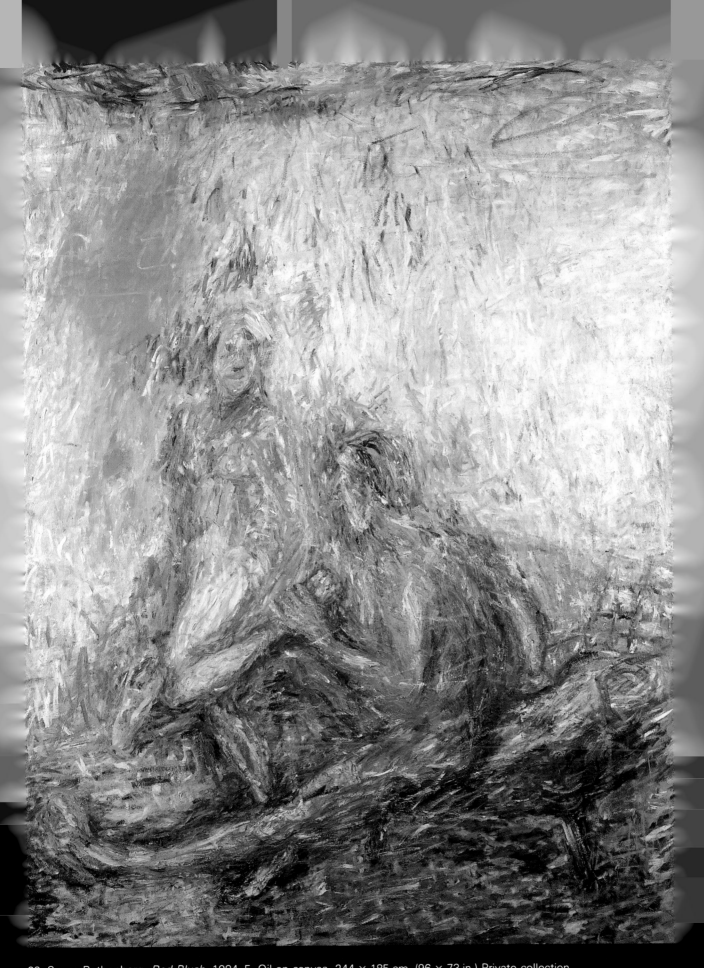

23. Susan Rothenberg. *Red Blush*. 1984–5. Oil on canvas. 244 × 185 cm. (96 × 73 in.) Private collection.

sued for breach of copyright by a commercial illustrator for using one of his drawings.

His use of pornography is at its most extreme in *Very Few Cars* (Plate 115) of 1985, one panel of which presents a large-breasted woman tied to a chair, while on the other a woman dressed in Mary Poppins clothes is scratchily drawn on lead; but a bright orange transistor is painted on the first panel in order to destroy the illusionism, just as on the other, an object is shoved under the lead. In uniting all these diverse elements, Salle operates like an interior designer, filling a room with carefully disparate things. In fact, it is their strong design sense that distinguishes Salle's paintings, giving a temporary (or potential) order to a disordered world and our perception of it.

Robert Longo's works likewise depend on design sense to hang together unlike objects (Plate 116). Salle, however, operates within the world of paintings – Longo is totally opposed to it. Whereas Salle has copied commercial illustrations, Longo has employed a commercial illustrator to do the work for him! Longo also creates performances and films as well as pictures. Whatever medium he employs, each piece is a carefully planned intervention into artistic and ideological thought. In Longo's opinion the artist works as a commentator on representation and on its uses and misuses in this world. For him, Schnabel and his ilk are artists wallowing in a decadent culture when they should reform it.

Much of what has happened concerning the transference of the abstract impulse into design and style in New York art, can be seen in Jedd Garet's work.

124. Susan Rothenberg. *Maggie's Cartwheel*. 1981–2. Oil on canvas, 63 × 77 cm. (24¾ × 30¼ in.) Private collection

125. Susan Rothenberg. *Bucket of Water*. 1983-4. Oil on canvas, 213 × 323 cm. (84 × 127 in.) Private collection

His *What the Earth is Really Like* (Plate 118) shows a simplified sculpture, a pair of axiometric drawings and a decorative swirl of green paint. This is a deliberately artificial world; his figures and images are conceived in terms of design. Garet plays not with abstract shapes but with bits and pieces from late de Chirico still lives and graphic design. His concern is with a mood or a look rather than with expressionism and gesture, hence his use of masking tape and the blending brush. His self-conscious use of style and sub-culture imagery is paralleled by many East Village artists.

Many of the artists who are now in their thirties were, if not actually hippies, certainly affected by the ethos of the late sixties. To some extent, the New Painting is a result of the hippy emphasis on creative individual freedom and expression. Inevitably, however, it is drug-taking that is the most conspicuous leftover of that period. The notorious heavy drinking of earlier artists like Jackson Pollock has been supplemented by, if not replaced with, the use of marijuana and cocaine. To radical East Village artists, drug-taking and art-making are both anti-establishment actions, a release of the human potentiality for experience. As the young painter Kenny Scharf says,

I never painted on mushrooms and I don't do them anymore, but I really got a lot of inspiration from them. On the ceiling I painted a fluorescent blue and orange spiral. I used to take mushrooms, lie on my back and stare at the spiral until it slowly dropped from the ceiling. I'd leave my body, go inside the spiral and float around in endless space.

126. Eric Fischl. *Bad Boy*. 1981. Oil on canvas, 168 × 244 cm. (66 × 96 in.) London, Saatchi Collection.

127. Eric Fischl. *The Power of Rock and Roll* (from *Rooms of the House*). 1984. Oil on linen, 305 × 223 cm. (120 × 88 in.) London, Saatchi Collection

Much of Scharf's art seeks to create the same euphoric disorientation of the senses. Keith Haring once said of Scharf's old Cadillac – that Scharf had covered with fluorescent paint, plastic dinosaurs and other technicolour kitsch – 'sitting inside it is like being on the most intense acid trip you've ever been on in your life, without after-effects'.

As anyone who has travelled through New York knows, all the subway trains have been covered with spray-gunned graffiti. Most of it is done by teenagers from the ethnic minorities as a form of gang warfare and bravado. The realization that this was a new 'underground' art with a potential market as a popular and living art-form led to a spate of gallery openings in New York's East Village in the early eighties. (Scharf, himself, opened one of the first of these, the aptly named Fun Gallery.) But with astonishing rapidity, the three major Village artists, Scharf, Haring and Basquiat – none of whom was a genuine graffiti artist – moved to SoHo galleries in a bid to establish themselves as serious artists rather than celebrities of a fashionable and passing fad.

Haring, however, is committed to a popular art, and still collaborates with teenage graffiti artists. His initial fame had come in 1980 at the age of 22, when he realized that the black paper that covered up old advertisements on subway platforms was an ideal surface on which to draw. Soon his cartoon-like figures appeared all over the New York subway system: faceless men, glowing babies, barking dogs, buzzing flying saucers and atomic explosions. These elegant white drawings became a day-by-day commentary on happenings in New York: he responded to the traumatic event of John Lennon's murder with the image of a dog jumping through a hollow-stomached man (Plate 117).

Haring's paintings and murals developed directly out of his subway drawings. For all their humour, his figures – part animal, part spermatazoa – have serious intentions (Plate 119). Just as we learn about the world as children through cartoon sex and violence, so Haring expresses his view of the world through these apparently degraded forms of art. His aim is to turn the reactionary ideology that they normally represent back on itself. Whilst applauding the free expression of sexuality, he detests the violence and insensitivity of a politically right-wing America. Typical of his social attacks is *USA 1981*, directed at the sexual hypocrisy of the Moral Majority: a drawing in which two faceless and sexually aroused men castrate a larger man who is bound upside down against a crucifix.

Scharf's first paintings were cartoon fantasies in which the Jetsons or the Flintstones became astronauts; these evolved into more complex renderings of cartoon figures imbued with life, or as post-nuclear mutants. A persistent feature was a background of spray-canned dots, a reference to Scharf's fascination as a child with a new colour TV to the point of watching its flickering dots from no more than two inches away. As he said,

I used to just sit down and hallucinate in front of the TV. . . . It didn't matter what you watched if you were that close to it, it was just colour. I remember watching the Kennedy assassination and my mother screaming all of a

sudden. I remember thinking, Why is she so upset? I see people getting murdered all the time. We always watched people getting shot on TV, and she never did anything.

Scharf's most impressive painting to date is the seventeen-foot-wide canvas *When the Worlds collide* (Plate 120). It is a sensory carnival: out of a luminous red mountain ridge looms a vacant-eyed and inanely grinning face; through its mouth we see a lunar landcape; while to its left drifts an equally banal face, half amoeba, half bubblegum. To the left of the painting a small orange figure crouches on a mushroom – it could be Scharf, or maybe ourselves as viewers.

Scharf is no innocent. Not only the mass media, but also past art is taken over and reprocessed in his paintings. In *Juicy Jungle* (Plate 122), the threatening but romantic jungle of Douanier Rousseau becomes a drug-distorted vision of a children's picture book. It is no longer the monsters of Nature that lurk in the undergrowth, but monsters of our own making. Painting brings them out in the open, where they cease to be threatening.

Although their work may seem at odds, Guston and Scharf share the same intention – that of intensifying our experience of the world. In different ways they show how we can transform that world. This serious, even utopian ambition, shines through Scharf's paintings: clarifying our vision of the world through the very images used to distort it.

The current doyen of East Village art, George Condo, is a contemporary of Scharf and a close friend of Walter Dahn. With his improvised poems, his paintings and his globetrotting, Condo seems very much a latter-day beatnik. Like the *Gruppe Normal*, with whom, despite being a New Yorker, he exhibits, his canvases are normally Surrealist pastiches in which images are pilfered from art history and the mass media alike. His picture of the world as part of his name is a typical flight of fantasy (Plate 121).

East Village art with its funk and opportunism is a very different phenomenon from the professionalism of artists such as Susan Rothenberg and Eric Fischl. Like the sub-conscious or the imagination, painting remains often inexplicable. We become exceptionally aware of this when charting the shifts and developments in Rothenberg's art. For all the power and capacity to move one that her paintings have it is difficult to pin down exactly what it is that so affects us.

Rothenberg was born in 1945. She began her horse paintings in 1974, but by 1978 this deliberate pictorial assault on the motif began to disappear as the imagery developed its own life and purpose. First the horse began to sit uncomfortably on its background, then it turned to gallop towards the viewer. At the same time it began to dissolve or fall apart in Rothenberg's feathery, flickering brushmarks – legs, heads or bones would appear separately. Soon human heads and hands began to appear, like strangers approaching in the fog.

Eventually Rothenberg began to expand this vision of potential shapes and presences by references to experiences of the real world. *Maggie's Cartwheel* (Plate 124) is about her young daughter. But it is not so much a description

of her cartwheeling as an evocation of the feeling of doing it; and, as so often with her, it is suffused with an almost visionary light. Like Le Brun she began as an abstract painter and the sensual delights in her paintings remain, like his, very much those of abstract painting, in spite of the gradual reconstitution of the figure.

Her paintings once conceived, Rothenberg is concerned with the surface of marks and textures. *Bucket of Water* (Plate 125) is exemplary: all the painting is in a shimmering atmosphere with an extraordinary pile of arms lifting a bucket over a head. The pictorial logic is such that we may almost miss the bizarre nature of the image: who is this levitated spectre behind the figure who is pouring water over itself?

Bucket of Water is painted solely in blues and whites. It is only with paintings such as *Red Blush* (Plate 123) that she began to bring reds and yellows into what was the colourless world of dusk. Again, the image is difficult to unravel: what is the relationship between man and woman? The crucial element in the painting, however, is the atmospheric suffusing of the red at the left, which is sufficient to allow one a sense of the couple's intimacy. Virginia Woolf once wrote of life being like a pulsating atmosphere or envelope around us; she could have been decribing Rothenberg's paintings.

Eric Fischl, like Salle, was originally an artist who created installations rather than paintings. In Fischl's case, they consisted of photographs, drawings and texts, all juxtaposed to explain our understanding of the world. Part of his reason for the choice of materials was a desire to reach a larger audience and to convey ideas, for as he said of himself, 'I grew up thinking art was the place where you looked for meaning; that it told you about life'.

This desire, as much as the inherent logic in his work, led him to turn to painting in 1979, but his attitude essentially remains, 'We don't need more paintings. What we need is meaning – more meaning'. His pictures, though they may seem shocking, are a moral approach to American culture. Central to his work

> is the feeling of awkwardness and self-consciousness that one experiences in the face of profound emotional events in one's own life. These experiences, such as death, loss, or sexuality, cannot be supported by a life style that has sought so arduously to deny their meaningfulness, and a culture whose fabric is so worn out that its public rituals and attendant symbols do not make for adequate clothing.

In his best-known painting, *Bad Boy* (Plate 126), a child stares at the open legs of a naked woman (his mother?) stretching on a bed, while at the same time he filches money from her purse (conceivably representing her vagina). The experience of the painting is simultaneously one of embarrassment and of fascination at being made privy to activities behind closed doors. But this is not mere moral voyeurism; too many questions are asked. Why is the boy bad: because he is looking at the woman, or because he is stealing the money? Does the over-sized bowl of fruit suggest the temptation and fall of Adam? (As a

128. Philip Guston. *Untitled.*
1969. Acrylic on panel,
46 × 51 cm. (18 × 20 in.)
Private collection

compositional device it gives us a child's point of view – something Fischl frequently does.) Above all else, we ask ourselves why is it painted with the deliberate slickness of the commercial illustrator? It is, perhaps, the central irony of Fischl's work that Middle America is trapped in the style most appropriate to it. The sliminess of his paintwork has more than formal implications.

Some of Fischl's images are unforgettable, epitomizing a whole culture and life-style. In *The Power of Rock and Roll* (Plate 127) a pre-pubescent boy dances naked surrounded by prestige symbols of success – the Warhol prints, the Rietveld chair. His Walkman is held aloft and with his eyes closed he dances to unheard music, isolated in a frenzy, a self-induced ecstasy, that ignores the world outside.

If we are in search of an icon of the twentieth century, this, in a negative sense, could be it; the denial of art and the imagination in preference to onanistic self-indulgence. It represents everything that the New Painters seek to overturn.

152

129. A.R. Penck. *Brown's Hotel*. 1984. Acrylic on canvas, 260 × 350 cm. (102 × 138 in.) Private collection

7 ━━━━━ AN ICON OF THE TWENTY-FIRST CENTURY

It is possible to look at painting again. It has an aura again. There is a light around the work. It is the same feeling, I think, that Renaissance people got from painting.
It is at times like this that art flourishes. Exactly why it happens is mysterious. The proof is the work of art and that is what is happening now. Sometimes I feel it couldn't be true, but at the same time I feel that something important – a certain miracle, a special connection – is taking place.

Sandro Chia

When in an interview in 1982 Sandro Chia spoke of this time as being another renaissance for painting it was, like the assertion that it was he who reinvented painting in 1977, strictly untrue. But there was an element of truth in it. There is no comparison to be made with the Renaissance: this age lacks it optimism and its sense of a unified intellectual community. However, there is now a resurgence in painting as a living and as a popular medium such as has not been seen in this century. Painting thrives as it has not for years.

Not only do all those artists we have examined in this book testify to this, so too do a great number of young painters who are emerging now. Most especially the extent of this 'explosion' of New Painting can be seen in the work we are beginning to see from outside those countries we have looked at. Our experience will no doubt in the future be further extended by the work of painters like Shinro Ohtake and Tadanori Yokoo from Japan, Peter Booth from Australia. Although one may associate New Painting in particular with Western Europe – and especially with Italy and West Germany – its implications, in this time of rapid international communications, are universal. One must always remember that New Painting is not a movement based on a formal invention or on a group manifesto, but is a reaction against the decadence of late-capitalist culture.

Painting has not been 'reinvented'; but its importance has been re-discovered. It is not the main visual medium as it was during the Renaissance, however, it is a vital corollary to those media (TV and photography) that are. In a period of economic and spiritual crisis not only does it maintain old traditions, but it encourages personal expression and confidence in the face of moral chaos and the manipulation of the individual by the state, capital and mass-media. Most of the artists whose work we have looked at actively oppose the shallowness and deceit of a complacent and decayed society – or at least began by doing so.

In the 1860s Fantin-Latour made a series of group portraits of his fellow artists as homages to their predecessors and peers; typically, in one we see Renoir, Zola and Monet gathered around Manet working at his canvas. A.R. Penck, perhaps consciously, parodied these homages when in 1984 he painted *Brown's Hotel* (Plate 129). In effect it is a homage to Baselitz whom he had known since the mid-fifties when they were both still in East Germany. The occasion is the night before the opening of Baselitz's retrospective exhibition at the Whitechapel gallery in London when Baselitz dined at Brown's Hotel. But, whereas Fantin-Latour, filled with pride in the vocation of the artist, shows Manet surrounded by other artists, Penck shows Baselitz eating an expensive meal surrounded primarily by art dealers. Dealers are essential now, as they have been for the last two centuries (and many of them, including some of these, have dedicated their lives to supporting art), but for them here to have taken the places of other artists suggests that this is not so much a homage to the artist as creative individual as a homage to the artist as a producer of prestige commodities.

The spectacle of the rebellious artist becoming an establishment figure is not a new one. The market is normally resilient enough to turn its most determined critics into supporters: such a change in Warhol and Rauschenberg is a recent one – marked in both cases by a notable decline in the quality of their work. But the speed with which many New Painters have achieved success and respectability is almost obscene: there has been no more saddening sight recently than that of certain painters posing complacently in their expensive suits at private views, whilst exhibited all around them are the hastily churned out repeats of those paintings that brought them fame. Fashion, marketing and painting are inextricably tied together in today's world: inevitably for some, such a heady mixture when mixed with success is corrupting. It is indisputable that the current reputations of many New Painters is grossly inflated. It must be also admitted that the output of many of these artists is uneven. As always, time alone will sort out the goats from the sheep, the good from the bad or meretricious.

But beyond all these disappointments, beyond all this time-serving, entrepreneurial chicanery and hype, one can still see the vision and utopianism that are the central thrust of New Painting. Anselm Kiefer's *Grane* (Plate 130) can serve to point out the seriousness and vigour that still characterize New Painting at its best. Grane is the name of Brunhilde's horse with whom she leaps into the flames at the end of Wagner's *Ring of the Nibelung*. From the flames will arise a new order; in this enormous woodcut the horse itself seems to rise like a phoenix out of the flames. The horse, a symbol that is at once heroic and poetic, is here an intermediary between us and the subconscious world of myth. Here, as elsewhere, Kiefer is seeking to re-integrate our normal experience with this world of myth, and with all our collective past. It seems that art alone can give shape to what otherwise will be repressed.

Above all else New Painting is concerned with the problem of the relationship between meaning and matter; and with the related question of how

130. Anselm Kiefer. *Grane*. 1982. Woodcut on paper, 166 × 157 cm. (65 × 62 in.) Private collection

we are to live in a seemingly dislocated and secularized world. Its concern with myth, the subconscious and the promptings of the irrational are part of a search for replacements for both organized religion and the now discredited notion of human progress through science, technology and social organization.

Walter Dahn's headless painter does not only search for an icon for the twentieth century, he searches for one for the next century. Beyond analysing current culture and *mores* he and other painters attempt, through their images, to establish a more complete way of experiencing and dictating the future.

A frequent image in Dahn's paintings is of his headless figures climbing up a monumental head with stairs cut into it. The body seeks reunification with the mind. This is, perhaps, above all others the icon that we desire: the image at the end of that journey so many figures in the paintings we have looked at – from Chia to Campbell, from Blais to Baselitz – have travelled. They return to their own face, their own mind; and that is what New Painting does for us: it leads us back, with a deeper comprehension, to our own images, our own minds and potentialities.

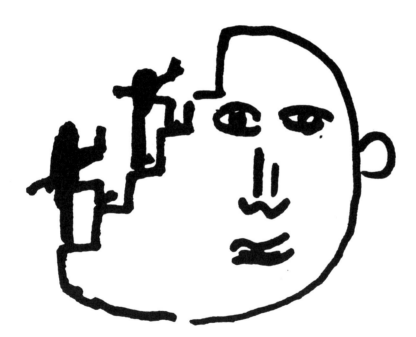

131. Vignette by Walter Dahn. 1984.

SELECT BIBLIOGRAPHY

Despite New Painting's dominance in the last few years very little good art criticism has accompanied it. Most of what there is has been published in the following English language art magazines: *Flash Art* (Italy), *Parkett* (Switzerland), *Artscribe* (England), *Art in America* (*USA*) and *Artforum* (USA). Apart from articles, these magazines often include interviews with the painters themselves which are sometimes revealing. Some of the most interesting are with Francesco Clemente (*Flash Art* No. 117, April/May 1984), Enzo Cucchi (*Flash Art*, November 1983), Eric Fischl (*Artscribe* No. 53, July/Aug. 1985), Ian McKeever (*Aspects* – UK – Feb. 1982). Per Kirkeby, one of the most articulate of artists, has also written a fascinating book of essays and reflections called *Selected Essays from Bravura* (published by Van Abbemuseum Eindhoven 1982).

Apart from the magazines, the most important sources of material, both written and visual, are exhibition catalogues. The catalogues for *Zeitgeist* (English edition published by Weidenfeld and Nicolson, 1983) and *A New Spirit in Painting* (published by the Royal Academy, 1981) are useful collections of pictures with somewhat disappointing essays attached. The large exhibition catalogue *Expressions* (published by the Saint Louis Art Museum and Prestel Verlag, 1983) is the best available survey of the older German painters.

Three important books are Achille Bonito Oliva's *The Italian Trans-avantgarde* (published by Giancarlo Politi Editore, 1980) which though now somewhat dated has been enormously influential; *Hunger Nach Bildern* by Wolfgang Max Faust and Gerd de Vries (published DuMont, 1982; 2nd edition 1986) and *Die Neuen Wilden in Berlin* by M. Klotz (published by Klett, 1984). The last two are unfortunately not yet translated into English.

Another invaluable source of colour photographs is the four volume catalogue of the Saatchi Collection in England which is by far the largest collection of New Painting in the world: *Art of Our Time: The Saatchi Collection* (Published by Rizzoli, 1984).

INDEX

Abate, Alberto, 83, *65*
Acker, Kathy, 129
Africano, Nicholas, 133
Alberola, Jean-Michel, 14, 113–17, *95, 97*
Anachronistici, 81–5, 96
Angermann, Peter, 56
Anzinger, Siegfried, 60–1, *50*
Arcangelo, 74, *58*
Auerbach, Frank, 89
Austrian painting, 59–61
Ayres, Gillian, 90, *74*

Bach, Elvira, 45
Bacon, Francis, 11
Balthus, 11
Bannard, Walter Darby, 12–13
Barcelo, Miguel, 118
Barfuss, Ina, 47
Barní, Roberto, 85, *69*
Bartlett, Jennifer, 136
Bartolini, Ubaldo, 83, *66*
Baselitz, Georg, 11, 21–9, 37, 39, 61, 80, 94, 96, 140, 154, *12, 13, 14, 28*
Basquiat, Jean-Michel, 136, 148
Beckmann, 10
Berlin, 21, 39–45, 48, 89
Beuys, Joseph, 16–17, 36, 58, *6*
Bioules, Vincent, 118, *98*
Blais, Jean-Charles, 110, 113, *91, 93*
Blake, William, 77
Bohatsch, Erwin, 60
Boltanski, Christian, 109
Bömmels, Peter, 45, 52, *39*
Booth, Peter, 153
Bronzino, 68
Brücke group, 28
Brüs, Gunter, 59–60, *48*
Buckley, Stephen, 124
Burgin, Victor, 9, 11
Büttner, Werner, 17, 57–8, *10, 44*

Campbell, Steven, 97–100, 110, *1, 81*
Cane, Louis, 112–13, *92*
Carpaccio, 65
Carrà, Carlo, 68
Carrol, Lewis, 33

Castelli, Luciano, 41
Celan, Paul, 38
Chevalier, Peter, 45
Chia, Sandro, 7, 11, 49, 68–70, 153, *3, 52, 54*
De Chirico, 11, 17, 45, 68, 77, 96, 145
Cilarz, Wolfgang, see Salomé
Claude Lorrain, 83
Clemente, Francesco, 16, 17, 48, 70, 74–80, 88, 94, 136, *7, 60, 61, 62, 63*
COBRA group, 11
Collaborative works, 17, 49, 60, 136
Cologne, 45–52, 70, 119
Combas, Robert, 105–9, 113, *88, 89, 90*
Condo, George, 149, *121*
Constable, John, 53
Correggio, 85
Cragg, Tony, 89
Cucchi, Enzo, 16, 48, 49, 65, 70, 85–8, 101, 133, *71, 72, 73*

Dahn, Walter, 16, 20, 39, 48–9, 56, 149, 156, *9, 11, 27, 34, 37, 131*
Daniels, Rene, 118
Davis, Brad, 132–3, *105, 110*
Devade, Marc, 105
Dezeuze, Daniel, 105
Disler, Martin, 61–4, *49*
Dokoupil, Jiri Georg, 17, 48–9, *8, 9, 38, 34, 36*
Dufy, Raoul, 129

East Village, 144–9

Fantin-Latour, Henri, 154
Farthing, Stephen, 100–1, *84*
Fetting, Rainer, 39, 44, 49, *30, 35*
Figuration Libre, 14, 105–10
Fischl, Eric, 17, 141, 49–151, *126, 127*
Freud, Lucian, 89
Fuseli, Henry, 77

Galliani, Omar, 85, *70*
Garet, Jedd, 144–5, *118*

Garouste, Gerard, 83, 113, *94, 96*
Gauguin, Paul, 74
Glasgow, 97–100
Golub, Leon, 11
Goya, Francisco, 74, 93
Greenberg, Clement, 9
Gruppe Normal, 56, 149
Guston, Philip, 120–1, 149, *102, 128*

Hacker, Dieter, 44, *33*
Hamburg, 56–8
Hammer, Mike, see Penck
Haring, Keith, 139, 148, *117, 119*
Heckel, Eric, 28
Heftige Malerei, 39–45, 61

Immendorff, Jorg, 16, 33–6, 49, *19, 21, 22*
Ingres, Jean Auguste Dominique, 83

Jarry, Alfred, 109
Jenney, Neil, 133, *108, 111*
Jensen, Bill, 125
Joachimides, Christos, 10
Johns, Jasper, 15
Jorn, Asger, 11
Judd, Donald, 9

Kapoor, Anish, 89
Kern, Georg, see Baselitz
Kiefer, Anselm, 16, 37–9, 52, 80, 85, 101, 104, 124, 133, 137, 140, 154, *23, 24, 26, 130*
Kirchner, Ernst Ludwig, 10, 28
Kirkeby, Per, 52–6, 101, 104, 157, *41, 42*
Kitaj, R.B., 89
Knap, Jan, 56
Koberling, Bernd, 52
Kokoschka, Oskar, 59
De Kooning, Willem, 11, 14
Kounellis, Jannis, 68–9
Kunc, Milan, 56, *43*
Kushner, Robert, 129–132, *104, 107*
Kuspit, Donald, 14

Lane, Lois, 133

Lange, Thomas, 45
Le Brun, Christopher, 94–6, 104, 150, *78, 80, 86*
Lewis, Wyndham, 101
Longo, Robert, 119, 144, *116*
Longobardi, Nino, 74, *57*
Louis, Morris, 80, 137
Lüpertz, Markus, 11, 29–33, 37, 39, 45, 48, *17, 18*

McConnel, Kim, 129
McKeever, Ian, 101–4, 85
McKenna, Stephen, 83, 96–7, *82*
McLean, Bruce, 89–90, *Frontispiece*
Manet, Edouard, 93, 154
Mangione, Salvatore, see Salvo
Mansfield, Andrew, 96, *79*
Marden, Brice, 77, 121–4, *100, 103*
De Maria, Nicola, 70, 81, 90, *64*
Mariani, Carlo Maria, 83, 85, *67, 68*
Matisse, Henri, 45, 118
Merlino, Silvio, 74, *59*
Merz, Mario, 68–9
Middendorf, Helmut, 39–40, 90, *31*
Mondrian, Piet, 121
Morley, Malcolm, 89, 94, 125–8, *101, 106*
Mulheimer Freiheit, 45–52
Murray, Elizabeth, 125

Naher, Christa, 52
Naples, 16, 70–81
New Image Painting, 14, 128, 133–6
New Spirit in Painting, 10, 15, 157
Newman, Barnett, 137
Nitsch, Hermann, 59

Oehlen, Albert, 57–8, *45, 46*
Ohtake, Shinro, 153
Olivia, Achille Bonito, 70, 121
Oulton, Thérèse, 90–2, 113, *75*

Paladino, Mimmo, 9, 70–4, *55, 56*
Parmigianino, 85
Pattern and Decoration, 128–33
Penck, A.R., 33–7, 49, 154, *20, 25, 129*

Picabia, Francis, 10, 77
Picasso, Pablo, 112
De Pisis, 68
Pittura Colta, see *Anachronistici*
Pleynet, Marcelin, 105
Polke, Sigmar, 16, 28–9, 37, 48–9,
 56, 117, 141, *15, 16*
Pollock, Jackson, 11, 14, 119, 140,
 145
Pop Art, 9, 15, 28, 39
Post-Modernism, 13–14
Poussin, Nicolas, 96, 121

Rainer, Arnulf, 59–60, *47, 48*
Rauschenberg, Robert, 15, 16, 124,
 154, *4*
Rembrandt, 17
Richter, Gerhard, 28
Rilke, Rainer Maria, 74

Di Rosa, Hervé, 109
Rothenberg, Susan, 136, 149–50,
 109, 123, 124, 125
Rousse, Georges, 117
Rousseau, Douanier, 149

Salle, David, 14, 16, 49, 117,
 140–4, 156, *113, 115*
Salomé, 17, 39–44, 49, 70, 90, *29,
 32*
Salvo, 65–8, *51, 53*
Savinio, Alberto, 68
Scharf, Kenny, 16, 145–9, *120, 122*
Schiele, Egon, 59
Schmalix, Hubert, 60
Schnabel, Julian, 11, 16, 49, 77,
 136–40, 144, *2, 60, 112, 114*
Scully, Sean, 125
Searle, Adrian, 104, *87*

Sevilla, Ferran Garcia, 118
Spanish painting, 118
Stella, Frank, 124
Still, Clifford, 140
Support/Surfaces, 105, 110, 118
Swiss painting, 61–4

Tannert, Volkar, 52, 92, *40*
Tintoretto, 90, 116
Titian, 90, 96
Trans-Avantgarde, 14, 65–88
Turner, J.M.W., 53
Twombly, Cy, 15–17, 77, *5*

Van Elk, Ger, 118, *99*
Van Gogh, Vincent, 17
Van't Slot, John, 118
Vautier, Ben, 109

Velazquez, Diego, 44, 112
Viallat, Claude, 118, 124

Wachweger, Thomas, 45
Walker, John, 92–4, 100, 112, *76,
 77*
Warhol, Andy, 15, 16, 136, 151,
 154
Wingler, Ralf, see Penck
Wiszniewski, Andrej, 97, *83*
Woodrow, Bill, 89
Woolf, Virginia, 150

Yeats, W.B., 74
Yokoo, Tadanoori, 153

Zeitgeist, 15, 89, 157
Zimmer, Bernd, 52

Photographic Acknowledgements

The author and publishers are extremely grateful to the following galleries and institutions for supplying photographs of the work of artists they represent.
Cologne, Karsten Greve, 5, 64, Max Hetzler, 44, 45, 46, Paul Maenz, 8, 9, 10, 11, 26, 27, 34, 35, 36, 37, 38, 39, 49, 51, 53, 54, 131, Monika Spruth, 43, 121, Michael Werner, 12, 13, 15, 16, 17, 18, 19, 20, 21, 22, 41, 42, 129; Düsseldorf, Heike Curtze, 47, 48, Gmyrek, 31, Innsbruck, Krinzinger, 50; London, Fabian Carlson, 29, 101, Gimpel Fils, 75, Nigel Greenwood, 76, 77, 78, 80, 85, 86, 99, Nicola Jacobs, 83, Knoedler, 74, Marlborough, 33, Mayor, 4, Anthony D'Offay, 2, 6, 7, 14, 23, 24, 28, 30, 60, 61, 71, 72, 130, frontispiece, Anthony Reynolds, 79, Saatchi Collection, 63, 111, 115, 126, 127, Edward Totah, 82, 84; Milan, Artra, 65, 66, Franco Toselli, 55, 56, 59; Munich, Bernd Kluser, 40, Tanit, 58; Naples, Lucio Amelio, 57; New York, Mary Boone, 103, 113, Carpenter and Hochman, 111, Xavier Fourcade, 106, David McKee, 102, 128, Metro Pictures, 116, Robert Miller, 118, Pace, 100, 114, Tony Shafrazi, 117, 119, 122, Holly Solomon, 104, 105, 107, 110, Sperone Westwater, 3, 62, 68, 73, Barbara Toll, 1, 81, Whitney Museum, 122, Willard, 109, 123, 124, 125; Paris, Durand-Dessert, 94, 95, Yvon Lambert, 88, 89, 90, 91, 93, Daniel Templon, 92, 95, 97, 98, 112; Rome, DueCi, 69, 70, Sperone, 52, 67; Zurich, Bischofberger, 32.